IMAGES
of America

LAKEWOOD

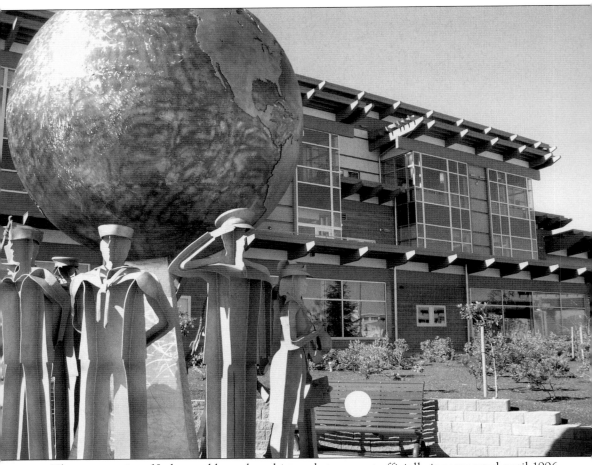

The community of Lakewood has a long history but was not officially incorporated until 1996. Its newest landmarks include a city hall and an award-winning veterans memorial by artist Jim Mattern, a Vietnam veteran, that highlights the community's links to the military. A volunteer committee raised money for the monument in part by selling personalized bricks laid into the sidewalk. As of this writing, memorial bricks may be purchased through city hall. (Courtesy Steve Dunkelberger.)

ON THE COVER: In the 1920s, Superintendent Dr. William Keller, boots dusted in dirt, stands proudly in front of just some of the extensive agricultural operations at Western State Hospital. Working in the fields was believed to be therapeutic for mental-health patients. The original Fort Steilacoom buildings are nestled in trees on the upper right. (Courtesy WSH Historical Society.)

IMAGES
of America

LAKEWOOD

Steve Dunkelberger and Walter Neary

ARCADIA

ISBN 0-7385-3045-X

Published by Arcadia Publishing
Charleston SC, Chicago IL, Portsmouth NH, San Francisco CA

Printed in Great Britain

Library of Congress Catalog Card Number: 2005929115

For all general information contact Arcadia Publishing at:
Telephone 843-853-2070
Fax 843-853-0044
E-mail sales@arcadiapublishing.com
For customer service and orders:
Toll-Free 1-888-313-2665

Visit us on the internet at http://www.arcadiapublishing.com

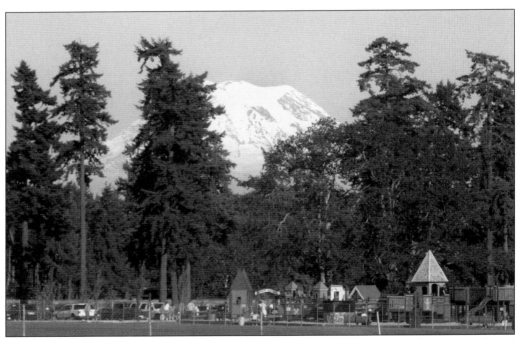

Lakewood residents don't always refer to Mount Rainier by its proper name. It often is referred to as "our mountain," not because it is located within the city, but because it is ever present in the background of daily life. Many old-timers think of the mountain as Mount Tacoma. Here the state's tallest peak hides behind trees at the Fort Steilacoom playground, which was built in 2005 through the coordination of the Rotary Club of Lakewood, the labor of thousands of volunteers, and tons of donated supplies and funding. (Courtesy Steve Dunkelberger.)

CONTENTS

ACKNOWLEDGMENTS

This book was a group effort. People graciously stepped forward with their advice, assistance, and photo albums to make it a reality. We would like to thank Cy Happy for allowing us access to his deep well of information and personal memories about growing up in Lakewood, as well as for his extensive collection of slides, gathered over the years while presenting the history of Lakewood to anyone willing to listen. He is a living treasure for his steadfast support, preservation, and presentation of our history. We know firsthand from trying to find the originals that without his collecting over the decades, many images would have been lost forever.

Special thanks also goes to Tacoma Public Library's Northwest Room staff, especially archivist Lare Mischo and communications manager David Domoski, for their helpful assistance and cooperation in the selection of photographs for this book. Photographs from the library are noted as TPL; many photographs are from its Richards Studio Collection, which is abbreviated as RSC. No reference to the library could be complete without mention of Gary Reese, who has done more to capture the documentary history of this region than anyone has yet to quantify. The information that he, Cy, and other predecessors have gathered anchors this book; though we apologize in advance for errors that we may have introduced.

We would be missing three chapters if not for Orville Stout and our fellow board members of the Historic Fort Steilacoom Association (HFSA); Alan Archambault, curator of the Fort Lewis Military Museum (FLMM); and Kathleen Benoun and the Western State Hospital Historical Society (WSHHS).

The project was endorsed early on by our fellow board members of the Lakewood Historical Society, and we are indebted to them and especially president Glen Spieth. Others to thank: Barbara Carman and her family; Peggy Bal, Admiral Russell's niece; Elizabeth Poinsett, daughter of Iva Alice Mann; the late Clary Holm, who collected irreplaceable scrapbooks of Lakewood history, and his wife, Dorothy Holm, and their daughter Susan Gierke; Kim Prentice and the Clover Park School District; Wilbur M. Snyder Jr., Gary Robinson, Mike Anderson and Clover Park Technical College; Dale Stowell and Pierce College; Paul Russell and Lakeview Light and Power; Stephanie Walsh and Lakewold Gardens; Pierce County Sheriff Paul Pastor and Det. Mike Portman; photographers Ed Kane and Stephen G. Bisson; Chief Paul Webb and Rachel Benz of the Lakewood Fire Department; Weyerhaeuser Company archivists Megan Moholt and W. Howarth Meadowcroft and George Weyerhaeuser; Dr. Wayne Herstad; Janda Volkmer; David Anderson; and Mandy Ma and Boo Han.

We owe special thanks to our families, who put up with our odd passion for an area that, as luck would have it, does not have just one place where you can find out about its history. We and other members of the Lakewood Historical Society will work on that problem next.

So now it's your turn. Please tell us what you know about what's in these photographs, or other parts of Lakewood history. And if you know of a photograph or artifact that should be in the collections of the Lakewood Historical Society, please hunt one of us down at www. lakewoodhistory.net.

INTRODUCTION

Lakewood has a long and rich history. The trick to learning about Lakewood history is that only recently has that history been under one name. Because this community was first nestled next to the oldest town in Washington—Steilacoom—and now sits next to one of the largest, Tacoma, there is much confusion about where Lakewood history begins and ends.

There are lots of names you have to include in your research. The prairies east of Steilacoom. The lands south of Tacoma. Lakes District. Lakeview. Clover Park. Tillicum. Pierce County. Camp Lewis (of course, later known as Fort Lewis.). That's just a partial list of the various identities and entities related to what we now happily call by one name: Lakewood.

Lakewood is special to us and many others, unique because it offers everything America as a whole offers, but in a fairly small geographic area. It has some of the wealthiest residents of the area, and some of the poorest. It has families that reach back to pioneer times and families who represent the influx of American diversity—particularly from South Korea and the Pacific Islands.

As you might imagine from the name, there are lakes and woods—a *lot* of lakes and woods. There is tacky commercial development, beautiful commercial development, streets that take your breath away, and the crowded, noisy streets you can find in almost any suburban city. There are parks and neighborhoods of great beauty that range from waterfront to deep woodlands. As this introduction is being composed, two deer graze and then look into the window of an 1858 cottage on the grounds of Western State Hospital. The deer can roam these grounds freely and calmly, while only a few minutes away, people rush up and down Interstate 5 as if they were torrents in a waterfall.

Lakewood was a place where people lived, loved, laughed, and learned together long before it ever became a city in 1996. We hope to give readers a sense of what Lakewood was like—and is like—as it transforms from prairie and farmlands, to a vacation area for the rich and famous of Tacoma, to a full-fledged community of Puget Sound. You only know where you are and where you are going if you know where you came from. What were once prairie lands have been replaced by homes and businesses, but the heart of Lakewood hasn't changed all that much since the first pioneers settled on the land those many generations ago. People of Lakewood seek their own way in life and form solutions when troubles arise. Neighbors in the early days of the last century had to work together to solve problems and form a community themselves since there was no government around to coordinate such efforts.

The Lake City Community Center formed decades ago as a grassroots effort, for example, to provide the Lakes District a place to meet and socialize. It is still in operation today. The Lakewood Playhouse Theatre is another example. It operated for half a century as a volunteer effort before it ever had a payroll and a permanent home stage to call its own. The Lakewood branch of the Pierce County library system also came because residents of the Lakes District wanted to quench their thirst for books locally rather than rely on some other entity filling that need.

Churches, schools, and service groups formed as a way to hold the community together and bound neighbor to neighbor through common goals and interests outside of just being a growing suburb of the City of Destiny.

This book happily coincides with two great events. One is the celebration of 10 years of cityhood in 2006. Not everyone approved of cityhood, and it's fair to ask tough questions. People certainly made mistakes. But the crime rate is down dramatically, and parks and streets have been improved. More important, people have a place to go when they want to discuss civic affairs. Lakewood has its own history. It deserves its own government.

The second event relates to plans underway to build a collection for the Lakewood Historical Society, and perhaps someday develop a museum. Things are happening, and we hope this book is a foundation for further efforts to identify and preserve our heritage.

Anyone who writes about the history of Lakewood stands on the shoulders of Cyrus Happy, a native and longtime collector of local history, seen here in his younger years with his father's cap (also seen on page 53), and Gary Fuller Reese, longtime librarian in the Northwest Room of Tacoma Public Library. We acknowledge with gratitude their decades of dedication to preserving Lakewood's heritage. (Courtesy LHS, Cy Happy Collection.)

One

FORT STEILACOOM

Many Native Americans refer to the epoch before white settlers came into their areas as simply "the time before." It was the time before people of European ancestry began fencing off the once-open fields; the time before fish no longer filled their baskets; and the time before the land was dotted with farmhouses, military outposts, and clusters of buildings the "Bostons" called towns.

One place in Lakewood is a key to the transformation from that "time before" to the time of change. Its grounds are the richest in the recorded history of the area.

Fort Steilacoom, located on the grounds of Western State Hospital near the border of Steilacoom and Lakewood, played a significant role in the settling of Washington and the Northwest.

The year was 1849. The Pacific Northwest was disputed territory between the young nation of America and the English empire. One battled for land to quench its thirst for expansion, while the other sought fur and trade goods to feed the consumer markets back home.

U.S. officials wanted to establish a foothold in the area to shift the balance of power from the British trade post Fort Nisqually and to protect the growing number of American settlers. A fight in August 24, 1847, at Fort Nisqually between natives had left American settler Leander Wallace dead. That was the signal. Bennett Hill's Company M of the 1st Artillery Regiment arrived at the scene. The British rented them the land for Fort Steilacoom on a farm recently made available by the death of Joseph Heath. The fort was the first official U.S. presence north of the Columbia River.

Soldiers at the fort provided settlers with a flow of consumers for their locally produced goods and a steady stream of currency, two much-needed commodities for civilizing an area. The fort doctor also provided medical aid to the civilians.

During the Indian War of 1855–1856, the fort served as headquarters for the 9th Infantry Regiment. About 80 settlers stampeded from around Puget Sound to the fort for safety. The handful of log buildings provided more security than their lonely farmhouses that were scattered around the prairie.

Apparently the fort was only attacked once. A sentry spotted something moving in the shadows during the night of December 28, 1855, and fired into the darkness. He reported later that he observed figures dragging away a wounded person. A patrol the following morning found a small trail of blood, but no body.

The war wound down in late 1856, but Fort Steilacoom still had a role to play. Gov. Isaac Stevens brought Leschi, leader of the Nisquallies, to trial for the death of volunteer Col. Abram Benton Moses during a skirmish at Connell's Prairie on October 31, 1855. Fort Steilacoom's Lt. Col. Silas Casey and many others maintained that Leschi wasn't even at the site of the killing,

and even if he was, war was war. Native Americans could not be held on murder charges for acts committed during a recognized act of war. The first jury couldn't decide the issue. Leschi was retried. Another jury sentenced Leschi to death.

Leschi was held at Fort Steilacoom during the trials, but Casey refused to allow the hangman onto the fort. The gallows were built just east of the fort. Leschi was hanged on February 19, 1856, after he climbed the scaffold and made the sign of the cross over his chest. A marker along Steilacoom Boulevard commemorates the solemn event.

Fort Steilacoom underwent a growth spurt after the Indian War years. Lt. August V. Kautz supervised construction of new buildings during 1857 and 1858. In 1861, the Civil War changed everything. Regular army officers stationed at the fort chose their sides and left for war. Fort Steilacoom was left to the territorial militia in 1861, while blue fought gray during the next four years.

With no coastal presence, Fort Steilacoom was abandoned as a military post in 1868. The Washington Territory received the 640-acre fort and farm, this time for use as what was then called an insane asylum. It opened in 1871. The military barracks housed mental patients and hospital staff. The buildings were used, remodeled, and mostly abandoned or removed as the hospital grew. The Historic Fort Steilacoom Association was formed in 1983 to restore the remaining buildings.

The Fort Steilacoom Historic District, with four renovated buildings, survives today as an interpretative center and museum.

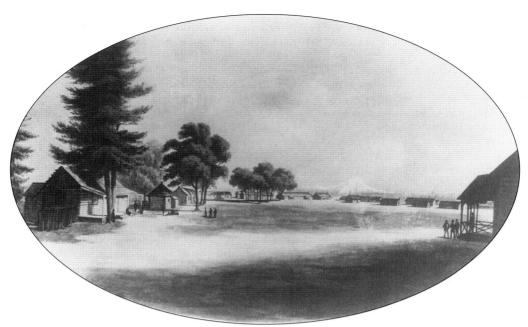

Fort Steilacoom was established in 1849 in the buildings erected by English farmer Joseph Heath, who had died a few months previous. The site was the first American military base on the Puget Sound. It sheltered settlers during the so-called Indian War of 1854–1856, but was never the scene of any fighting—a blessing, since the only fortification was a picket fence. (Courtesy Historic Fort Steilacoom Association.)

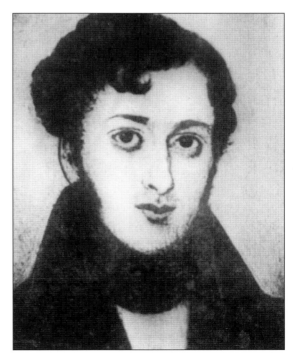

Joseph Heath, pictured here about 1844, died on March 7, 1849, of pneumonia and a heart condition. He had lived a hard life in what was then a lonely land. As current Lakewood gardeners know, the soil is filled with gravel. Heath's diary is often a document of despair for other reasons, particularly when mail did not arrive as expected. "Constantly grieving to think that I am forgotten by nearly all dear to me," he wrote shortly before his death. Before that, however, he was cheered by a long-delayed package from home. (Courtesy HFSA.)

11

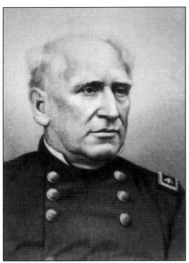

Fort Steilacoom commander Lt. Col. Silas Casey's leadership of the 9th Infantry during the so-called Indian Wars of 1855–1856 and the "Pig War" over the San Juan Islands showed compassion toward natives and an interest in peace. However, Casey had a distinguished record in the Mexican War and would go on to serve in the Civil War. Civil War reenactors use his book on military drilling and procedure today. (Courtesy HFSA.)

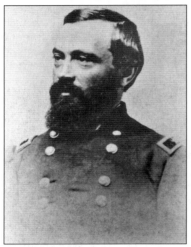

Lt. August Kautz supervised the construction of permanent fort buildings in 1857–1858, even though many soldiers deserted at reports of a gold strike on the Fraser River in Canada. Four buildings of his era form the present museum. Kautz was among the first people of European descent who attempted to climb Mt. Rainier; he got within 400 feet of the summit before turning back. Kautz complained that ground blackberries were almost the only available food. Unlike many of the soldiers who had children with native women, Kautz took responsibility for two sons he fathered with an American Indian wife and provided a monthly fund for her and the children. Members of the family are leaders of the present-day Nisqually Tribe.

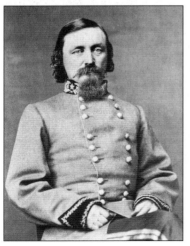

When an American shot a pig belonging to an Englishman on the San Juan Island, hotheads wanted to bring the two countries to a border war. From Fort Steilacoom, Capt. George E. Pickett established a base on the island. Officials from Washington, D.C., told everyone involved to calm down, and the two countries settled the boundary in other ways. That was a good thing because Pickett described his army base as a "mere mouthful" for the nearby British military. Pickett went on to fight in the Civil War and give his name to a famous charge at Gettysburg.

Lt. William Slaughter, pictured here with his wife, Mary, in 1852, died in the Indian War of 1855–1856. Mary operated the officers' mess hall at Fort Steilacoom, while her husband helped plat the nearby town of Steilacoom, where he also bought lots in support of those who assumed the thriving port town would someday be the next San Francisco. Slaughter sat with Gov. Isaac Stevens during the Medicine Creek treaty discussions. American Indians were dissatisfied with

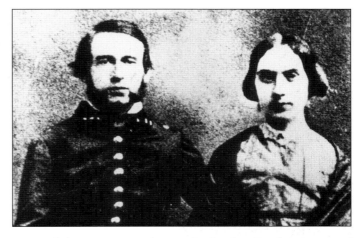

the results of this and other treaties, and there were casualties on both sides. On the evening of December 4, 1855, Slaughter was conducting a planning meeting at camp along the Green River. He had allowed fires to be built for warmth and cooking. The fires created a tempting target, and Slaughter was shot and killed. The town that eventually was established where he died was first called Slaughter, but the name was later changed to Auburn. He was buried at Fort Steilacoom in a cemetery that still exists on the grounds of Western State Hospital; however, he and other soldiers were moved by the army to the Presidio in San Francisco when the fort was transferred to civilians. (Courtesy HFSA.)

Puyallup pioneer Ezra Meeker sought shelter at Fort Steilacoom during the Indian War and provided the most popular quote about that period: "A sorry mess . . . of women and children crying; some brutes of men cursing and swearing; oxen and cows bellowing, sheep bleating; dogs howling; children lost from their parents; wives from husbands; no order, in a word, the utmost disorder." (Courtesy HFSA.)

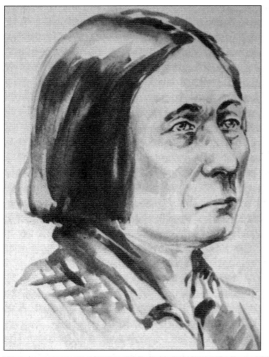

Leschi of the Nisqually tribe was linked to most of the famous attacks of the Indian War, whether he was anywhere near the battle or not. Settlers assumed that the American Indians had an equivalent to their own leader, Gov. Isaac Stevens. Many prominent settlers, including Meeker, believed the chief was innocent and was a scapegoat for tensions of the war, but a jury convicted him. Though Leschi was confined at the fort, Casey refused to let him be hanged on the grounds. Civilians hanged Leschi on February 19, 1858, near where Steilacoom Lake meets present-day Steilacoom Boulevard. A monument in an Oakbrook shopping center denotes the general area of the scaffold. It wasn't until 2004 that the state legislature formally exonerated him. (Courtesy HFSA.)

Lieutenant Kautz and other soldiers performed measurements in Connell's Prairie to demonstrate that a witness in Leschi's trial could not have seen what he claimed. The soldiers then published this newspaper seeking to prove Leschi was innocent. Publisher Charles Prosch later used the same printing press to produce the *Puget Sound Herald*, the first consistent newspaper for Steilacoom and the prairies that would become Lakewood. (Courtesy HFSA.)

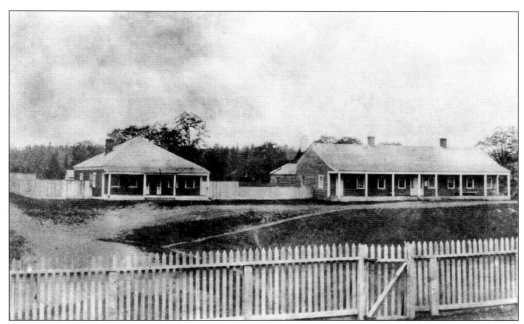

During the Civil War, Fort Steilacoom was staffed by volunteers from such places as California, some of whom said they would have preferred to be closer to the action. The reduction in services at the fort contributed to a decline in the local economy. The federal government closed the fort in 1868, and in 1870, the territorial legislature paid $850 for the 25 buildings. In 1871, the first patients at the new hospital moved into the former barracks. (Courtesy HFSA.)

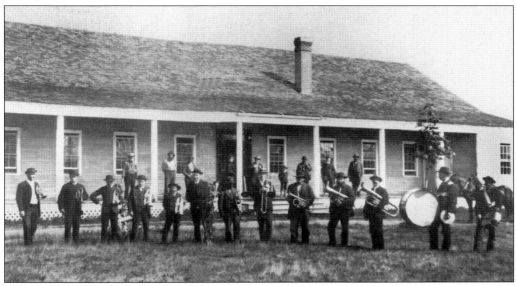

These are musicians from an early period of Western State Hospital. This photograph and the one above show examples of the fort buildings that did not survive. The four buildings that do remain are examples of officers' living quarters. (Courtesy HFSA.)

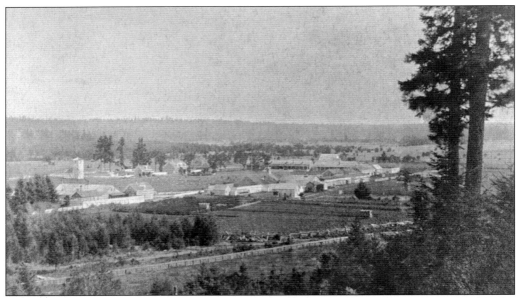

This *c.* 1860 photograph shows the fort at its peak. This photograph was taken from roughly the same spot as the photograph on the cover. (Courtesy HFSA.)

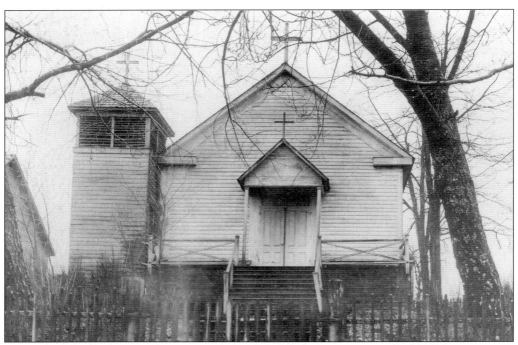

In 1855, soldiers volunteered to build Immaculate Conception Catholic Mission because the army only supplied a chapel for Protestant worship. The Catholic building was moved to Steilacoom in 1864 and now has the view of Puget Sound that soldiers would have only wished they'd had from the inland fort. The church continues to host services as part of the church mission of Lakewood's St. John Bosco Church. (Courtesy HFSA.)

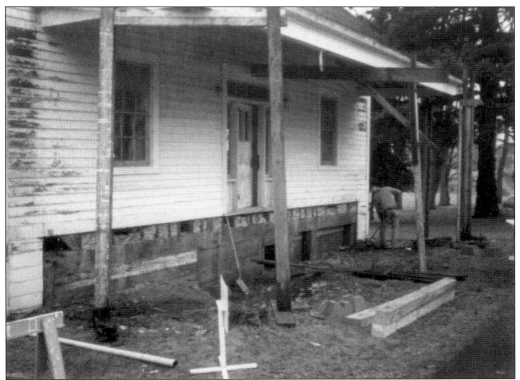

By the 1970s, the four surviving buildings that Kautz erected were in sad shape. A group of volunteers marshaled the community to donate materials, money, and time to save the structures. Work continued throughout the 1980s. This photograph shows Quarters No. 4, during reconstruction of its porch. (Courtesy HFSA.)

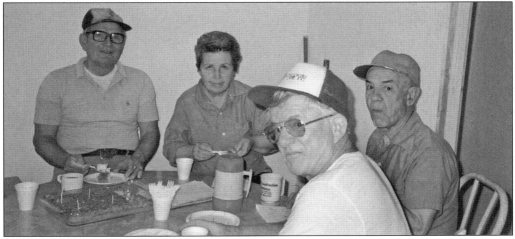

Chuck Collier, Lou Dunkin, Bob Weir, and Lyle Dunkin, volunteers who led rebuilding efforts, pause for a coffee break during reconstruction. (Courtesy HFSA.)

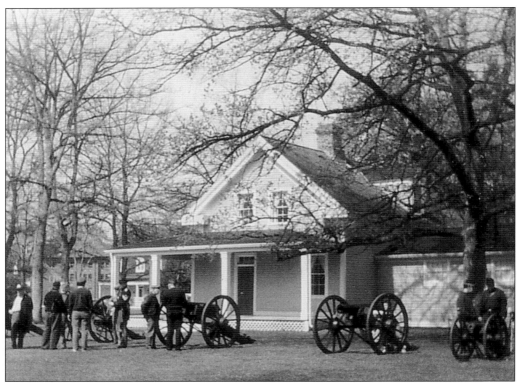

This is a modern view of the former chaplain's home and worship area. More than 300 organizations and hundreds of volunteers contributed thousands of dollars and hours to restore this and the other three remaining buildings. Of the four, this building was in the worst shape before reconstruction. Volunteer Chuck Collier remembers standing in the middle of the building—where raccoons found shelter—and looking up past the remnants of a roof into open sky. (Courtesy HFSA.)

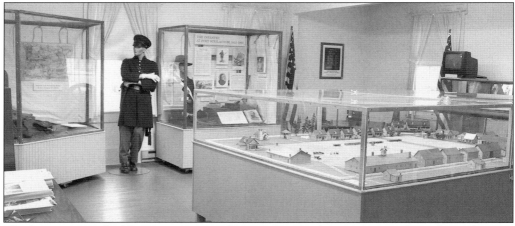

The four remaining buildings are now part of Historic Fort Steilacoom Museum (www.fortsteilacoom. org). The museum's displays and a diorama constructed by volunteer Bob Demorest illustrate the extent of the fort in the 1850s. Fort Steilacoom was very much a precursor to nearby Fort Lewis—which, like Fort Steilacoom in pioneer times, is a major force in the local economy and protection of our nation's interests. (Courtesy HFSA.)

Two

THE PIONEERS ARRIVE

The U.S. Army's founding of Fort Steilacoom encouraged settlers to plat towns, form municipal governments, and raise church steeples. The nearby settlement of Steilacoom is called the "place of firsts" because it holds several of Washington's firsts. For example, it was the first officially incorporated town in the Washington Territory.

Fort Steilacoom not only brought protection, hard currency, and government, it also brought the organizational structure from which the greater Puget Sound relied. Roads such as Old Military Road, Steilacoom Boulevard, and even what is now Interstate 5 radiated from military operations headquartered at Fort Steilacoom.

The settlers of the area raised crops in their outlying farms and used those roads to either bring their goods to sell directly to the military or to the residents of the growing town of Steilacoom.

Residents of what is now the city of Lakewood were a diverse bunch even then. They included people from the Pacific Islands who journeyed across the sea with English or American ships to work in unknown lands, as well as Irish and German immigrants, who each formed about one-third of the soldier population, leaving their lives in Europe for adventure in the frontier . . . all mixed together on the prairie lands of Lakewood.

Probably the best-known settler of this era was Thomas Chambers. In 1849, Chambers staked a 640-acre claim at the mouth of Heath Creek, today known as Chambers Bay. By 1850, the United States had still not compensated English officials for their land holdings considered in the United States. Since they had received no compensation and still held the title to the land, English officials refused to recognize claims on their land and sometimes tried to evict settlers for trespassing. One story claims that an English agent had been repeatedly harassing Chambers and his family to get off his land. The last time the agent came to evict the Chambers family for trespassing, Chambers ran the man off with the barrel of a shotgun.

With the construction of a gristmill in 1850 and a sawmill in 1852, Chambers set a precedent for industrial development along Chambers Creek. The gristmill was operational by 1852 and was being used by local citizens and, ironically, by the remaining English officials. The first year of Chambers's foray into local politics, 1852, he was elected to serve as a county commissioner for the newly formed Pierce County. Shortly after, he was elected probate judge. Always known as a fair man, residents continued to call him "Judge Chambers" for the remainder of his life.

Another notable pioneer was Willis Boatman, who brought his family to the Washington Territory shortly after the area separated from its southern neighbor, Oregon, in 1853. The family had a harrowing crossing that has been profiled in books by his descendant Weldon Rau. Most folks who crossed the Oregon Trail went to Oregon because the Puget Sound was nothing but

wilderness and empty fields. Boatman worked in a lumber camp owned by Steilacoom founder Lafayette Balch. The Boatmans moved to the forested area of the Puyallup Valley just as the Indian Wars started up in 1855. Boatman had always treated the American Indians with friendship and respect. One American Indian liked Boatman so much that he secretly told Boatman about a coming attack on the night of October 28, 1855. The Boatmans, along with every other family in Pierce County, headed for the safety of Fort Steilacoom. The march was 16 miles across the prairie, and the rush caused many families to leave their few valued possessions behind. The 18 families evacuating from the Puyallup Valley shared one wagon for all of their supplies.

The Boatmans later returned to their house to find it was the only building left standing in the Puyallup area. Boatman's American Indian friends apparently spared his home.

The Boatmans also built a house in what is now Lakewood—the first property the city of Lakewood designated as a local landmark. The structure stands along 112th Street, across from Clover Park High School, and a mystery surrounds that house. It was the site of the 1857 kidnapping of Boatman's two-year-old son John, who had been playing in the yard. His mother, Mary Ann Boatman, was working in the kitchen when she decided to look for him. John had disappeared. Search parties scoured the countryside and even dragged the lake. They found nothing.

Fort Steilacoom's commander, Lt. Col. Silas Casey, threatened to kill any American Indian he found connected to the kidnapping. The common theory of the day was that the American Indians kidnapped the boy to hold as ransom in exchange for Leschi, who was facing the gallows for his role in the recently ended conflict.

One day, the searchers heard a shot and ran to the scene. They found John unharmed. The mysterious part about his appearance was that he was completely dry, even though it had been raining all day. Townspeople believed the boy was kidnapped and rolled in a blanket to muffle his cries, because after his recovery, the boy was fearful of blankets.

The Boatmans later returned to the Puyallup Valley. Willis Boatman became one of the most prominent hops growers in the area. He also helped develop the roads system and form the Farmers Bank of Puyallup.

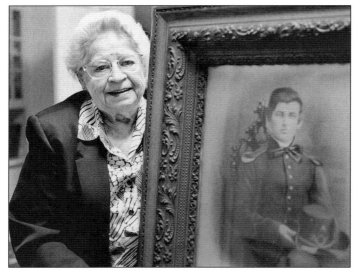

Helen Peterson of Lakewood displays a drawing of her ancestor, William Stephen Hipkins, who homesteaded part of Lakewood after serving two tours in the Union Army during the Civil War. He started his journal with his hat and shoe size, but went on to document his duties during Gen. William Tecumseh Sherman's infamous march to the sea. Hipkins settled in the Lakewood area in 1867, with a land claim just west of Steilacoom Lake, known as Byrd's Lake at the time. Hipkins worked as a carpenter and built several houses around Lakewood. He and his wife raised four daughters and a son at the family farm at what is now Hipkins Road and Ninety-fifth Street. Hipkins donated land for the prairie road, which was dedicated in 1898. He died in 1901. Around 1908, the homestead burned down. (Courtesy Steve Dunkelberger.)

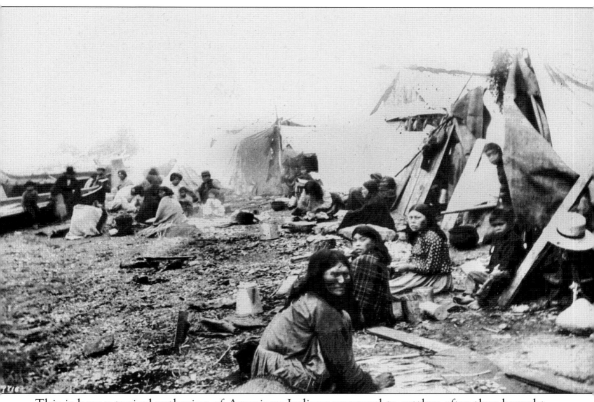

This is how a typical gathering of American Indians appeared to settlers after they brought European ways, and photography, to the area. An ancient fishing village has been identified along the north spit of Chambers Bay. The anglicized name of the tribe is Steilacoom. The tribe was a small group of Puget Salish speakers who lived along the east shore of Puget Sound across from the Anderson, Fox, McNeil, and Ketron Islands, and has been closely linked by ethnographers to the Puyallup and Nisqually tribes. These three tribes generally spoke the same language and had the same culture of hunting and gathering. The tribe runs the Tribal Cultural Center in nearby Steilacoom and is fighting for federal recognition as a tribe. Thus far, their official status has been denied. (Courtesy LHS, Cy Happy Collection.)

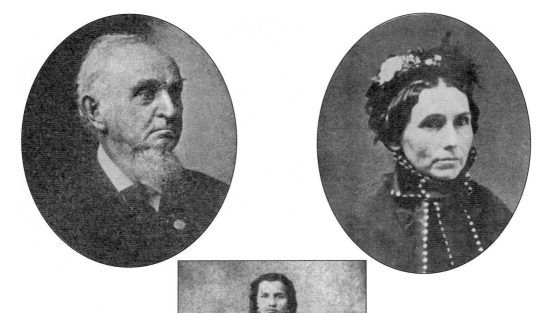

None of Lakewood's early settlers, besides August Kautz, left extensive records of life in pioneer times—to the great agony of future historians, including the authors of this book. Thankfully, though, William Pierce Bonney wrote one of the most extensive early histories of Pierce County. So it is not surprising that something is known of his parents, Sherwood and Lydia Ann Bonney. In 1853, long before American Lake attracted the rich and famous of Tacoma—in fact, long before Tacoma—Sherwood Bonney crossed the Oregon Trail and settled on 322 acres next to the lake. His first wife died on the trail and was buried under a tree. He later married the widow of his brother, who had also died on the trail. Mary Shorey, Lydia's daughter by her first husband, would later write of American Lake, one of Lakewood's three largest lakes that had been the scene of the first Fourth of July ceremony in the Washington Territory. "It was a veritable park, the shores of the lake being fringed with wild roses, and underneath the spreading oak trees the violets and buttercups made a carpet dainty and beautiful," she wrote. Sherwood Bonney was the first justice of the peace, responsible for officiating many early marriages. In the summer of 1854, Lydia taught the first formal school classes for 27 Pierce County students in their living room. The living room was later replaced by the stand-alone Byrd School. William, Mary's brother and future historian, was born while the family sheltered in Steilacoom during the Indian War. Mary wrote that his birth brought the family to an even dozen, "a pioneer family always having room for one more." (Courtesy LHS.)

Perhaps by looking into the eyes of Willis Boatman, right, and his son John, pictured about 1924, one can come close to feeling the pioneer experience. Boatman built Lakewood's oldest surviving home, and also helped build the structures at Fort Steilacoom. He moved to 120 acres in Lakewood across from what is now Clover Park High School, but later returned to the Puyallup Valley. One of his descendants, Weldon Rau, has written histories about the family and the area. (Courtesy TPL Marvin B. Boland Collection G1.1–024.)

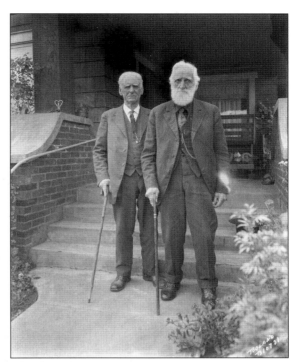

This view of the Boatman house was commissioned in 1954, 100 years after its construction, by the Orrs, who lived in the house after the Boatmans and Capt. J. C. Ainsworth, a Tacoma businessman. Dwight Orr was an officer of the Weyerhaeuser Company. Many members of the company, including its owners, settled in Lakewood and have become community leaders. Some Lakewood residents remember a barn of post and peg construction, near the house, that had to be torn down. (Courtesy TPL RSC, D80292–9.)

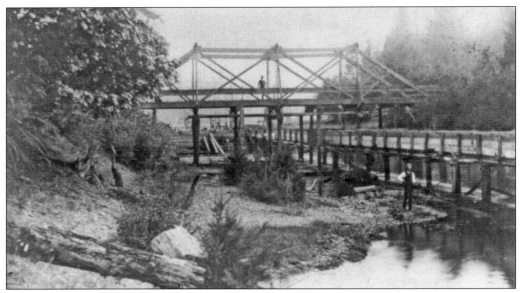

In 1853, Andrew F. Byrd filed a claim for 159 acres at the north end of what is now Steilacoom Lake, in an area near the current corner of Steilacoom Boulevard and Phillips Road, where Steilacoom Lake feeds into Chambers Creek. In partnership with his brother Preston Byrd and A. E. Light, a Steilacoom merchant, Byrd built a dam and sawmill, both of which are seen here. The dams required by the mill backed water up into a nearby valley, thus boosting the level of Steilacoom Lake. (Courtesy LHS, Cy Happy Collection.)

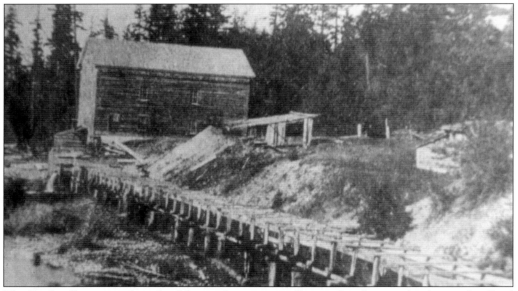

The Byrd mill converted much of the area's grains into flour and timber into lumber, and its Byrd Mill Road became a popular route between Puyallup and Steilacoom. Among the people who worked at the mill was Job Carr, whose cabin has been reconstructed in Tacoma. Historian Murray Morgan wrote that Carr found occasional employment at the mill "while waiting for the city of his dreams to materialize." In the late 1880s, some of the Byrd land was platted for a town named Custer. The name remains on a road and a school. (Courtesy LHS, Cy Happy Collection.)

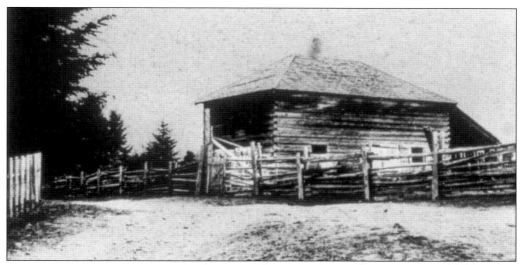

The Bradley blockhouse was built in the Custer area in the late 1840s, thus predating Fort Steilacoom's current buildings. The log barn was used as a shelter during the Indian War of 1856 and 1857. In 1889, the Flett family built their home over the site of the barn; in the 1950s, the home was moved about 300 feet to make room for a gas station. The Lakewood Historical Society later marked the original site with a boulder. John Bradley was Pierce County's first sheriff, and he settled on a claim next to the Byrds. (Courtesy LHS, Cy Happy Collection.)

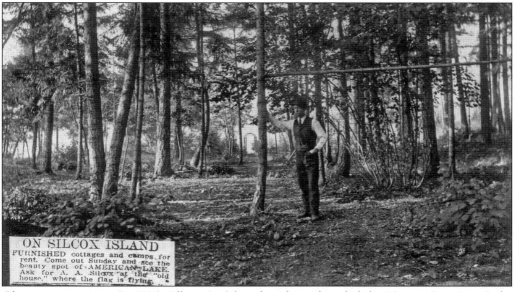

Change was coming. In 1905, Albert A. Silcox bought and settled the 13-acre American Lake island that bears his name as a place to get away from the bustling urban life of Tacoma's 20th-century streets. A newspaper advertisement inserted into this photograph by the family shows that he eventually sold lots—a process that would take place throughout Lakewood. (Courtesy LHS, Family of A. A. Silcox Collection.)

Various dams have been constructed over Ponce de Leon Creek, which runs into Steilacoom Lake. This picture shows the Clarke family in the early 1900s. Although part of Ponce de Leon Creek was paved over with construction of the Lakewood Mall and covered by a bank building (for unclear reasons), the creek continues to flow under Gravelly Lake Drive. (Courtesy LHS, Cy Happy Collection.)

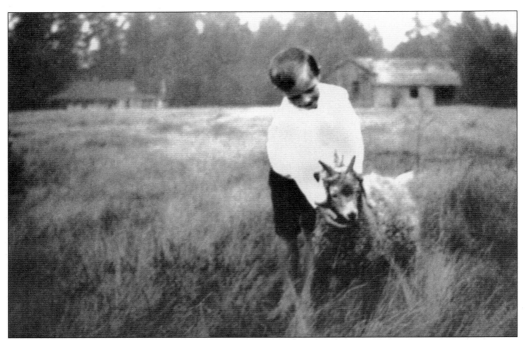

Around 1900, Fred Clarke and a goat enjoy the prairie along Ponce de Leon Creek. The former Park Lodge station of the Tacoma-Lake City Railroad later became a house, seen here at left. The Davisson homestead is on the right. (Courtesy LHS, Cy Happy Collection.)

Three

SCHOOLS BIND THE COMMUNITY

In 1999, accompanied by a metal detector and camera, Lakewood historians Glen Spieth, Steve Dunkelberger, and Cy Happy walked into the woods at the corner of Steilacoom Boulevard and Lakewood Drive. They found the site within minutes: Byrd School. It was the first recognized school in Pierce County and planted the seed of what would later become the Clover Park School District.

The historians waded through the hip-high grass and dug into the dirt, as the Goldmaster metal detector happily buzzed. They found a handful of nails, a few pieces of fire-glazed pottery, some bits of melted glass, a four-inch square piece of an iron stove, and a metal ring from an oil lamp in less than an hour of searching. The artifacts were put on display in Lakewood City Hall.

The Byrd School was first built in 1855, at what is now Park Lodge Elementary School. To make it more centrally located, it was moved in 1856 to the W. P. Dougherty land claim, later known as part of the Flett Dairy property at Steilacoom and Lakewood intersections. In one room, the school housed about 20 students of all ages.

Settlers wanted a school around the western edge of Steilacoom Lake instead. They got what they wanted in 1885, when the Byrd school burned to cinders, the victim of an "accident" that remains debated to this day. The school burned in a fire one weekend, legend has it, and was replaced with one closer to the lake. "The kids were told to bring their books home that weekend," says Lakewood historian Cyrus Happy. The fire "is one of those things that was whispered about."

A rock monument, found behind the thick row of bushes near the corner of Steilacoom Boulevard and Lakewood Drive, just beside the Lakewood Fire Department station, marks where the Byrd School, built with the aid of prominent settler and mill operator Andrew Byrd, once stood. The monument notes that the school was constructed about 160 yards to the north.

Frontier schools like this operated around the Lakes District for decades. School officials made sure not to hamper the planting or harvesting schedule, and sent the upper grades to the school district in Tacoma. Teenagers would have to take the cross-prairie trolley car to classes in the City of Destiny. Some went to Stadium High School, while the more well-to-do families sent their children to the private schools. That system worked when numbers were small, but the prairies of Lakewood were adding homes at a rapid rate. They wanted schools of their own. Each elementary school operated independent of each other.

A clerk for the Park Lodge School and other folks saw the need for an institute of higher learning—a junior high. Iva Alice Mann, referred to by many as the mother of the Clover Park School District, helped combine the Park Lodge, Custer, Lake City, Lakeview, and American Lake South schools into one district. The Clover Park School District was born. The combination allowed for a junior high under the name Union School District No. 204 in 1928. Mann watched the district grow and, in 1941, even helped another consolidation that created Clover Park School District. Iva Alice Mann Middle School was dedicated in her honor on September 3, 1959.

The district expanded to include the nearby military bases of Fort Lewis and McChord Air Force Base in the late 1970s, adding a sense of international flavor that remains to this day. The district mirrors Lakewood, which has some of Washington's best housing and, in some neighborhoods, some of its poorest. Test scores have suffered in recent years, and it has been fashionable for many people—especially those who remember the test scores of a more compact Lakewood—to knock the district.

However, the latest scores have been improving, and it is widely believed that a student's education has much to do with his or her parents or mentors. Parents who move into good neighborhoods will find there are good schools there; parents who move into troubled neighborhoods will find good schools that are deploying a variety of innovative approaches, from role-modeling to after-school programs, to manage the social and educational challenges of the day.

The school district is one element of Lakewood's active participation in the America's Promise movement for youth, whose founding chairman is former secretary of state Gen. Colin Powell. The organization has often singled out Lakewood for exemplary programs and youth involvement.

Teacher C. J. S. Greer, his wife, and daughter are pictured outside their home, about 1875. They lived near the railroad in Lakeview, one of Lakewood's first communities. Greer's students were graded for both deportment and scholarship. (Courtesy LHS, Cy Happy Collection.)

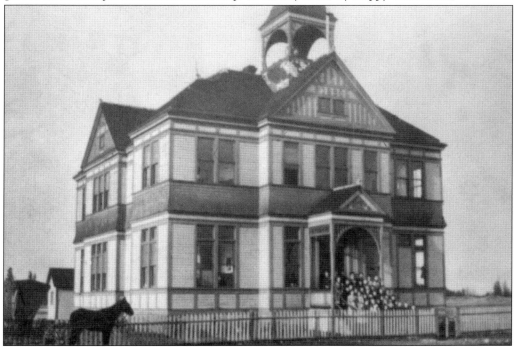

Lakeview School, visible here and on page 99 in the upper right corner of the aerial photograph, eventually burned. (Courtesy LHS, Cy Happy Collection.)

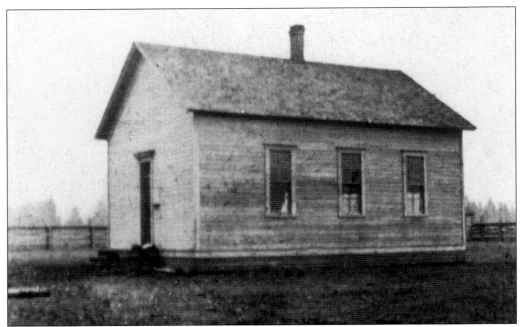

The first school north of the Columbia River, the Byrd School, was built on Augustus J. Knight's land claim, to provide more room for students than Mrs. Bonney's front room. The school educated about 20 students of all ages in one room. The school was later moved near Lakewood Drive and Steilacoom Boulevard. In 1885, the school burned to the ground, an "accident" whose cause remains debated to this day. (Courtesy LHS, Cy Happy Collection.)

This is an early view of Park Lodge School, built in 1912, before it received a distinctive cupola as part of an expansion about eight years later. In a controversial decision, the Park Lodge was demolished and replaced with a new building on the same site. The cupola is now in the entry hall. (Courtesy LHS, Cy Happy Collection.)

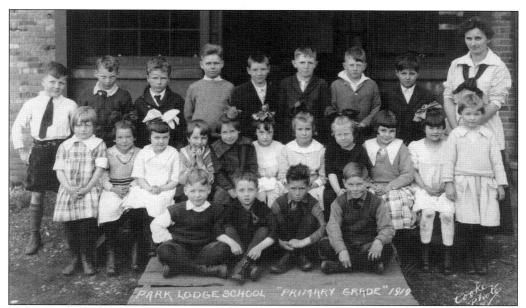

This 1919 Park Lodge class photograph is typical for this time period. At 94, Elizabeth Poinsett (middle row, fourth from right) remains active in the Lakewood Historical Society in part by calling other board members to remind them of meetings. Her mother, Iva Alice Mann, helped found the Clover Park School District that helped give Lakewood its cohesive identity. (Courtesy Elizabeth Poinsett.)

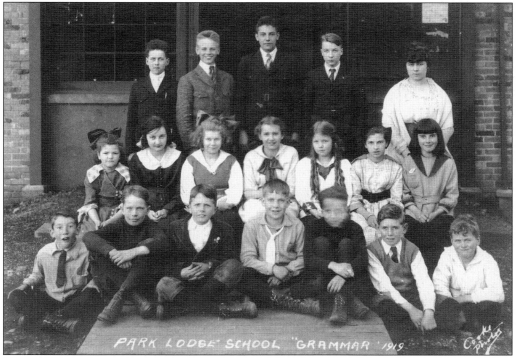

These older students, also from Park Lodge, posed for a class photograph in 1919.

The Dekoven School for Boys was a private school named after a Wisconsin educator. The school operated from 1895 to 1919 before it became the Dekoven Inn. Several buildings from the school remain, though they have been altered over the years. (Courtesy LHS, Cy Happy Collection.)

In 1933, students proudly posed in front of the one-year-old Custer School. In 1953, the Clover Park School District built a larger school complex. Known as the Little Red School House, this building survives and was listed on the National Register of Historic Places in 1987. (Courtesy TPL, RSC, 470-2.)

This c. 1918 photograph shows the Wheeler family with Iva Alice Mann, below left. (Courtesy LHS, Cy Happy Collection.)

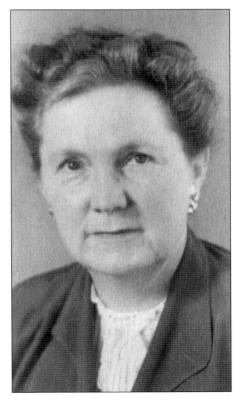

Iva Alice Mann, referred to by many as the mother of the Clover Park School District, was clerk of the Park Lodge School District in 1923 when she helped combine the Park Lodge, Custer, Lake City, Lakeview, and American Lake South schools into one district. In 1928, the combination allowed for a junior high school under the name Union School District No. 204. Mann helped to bring the first superintendent, Arthur Hudtloff, to the district, setting up a longtime partnership in community improvement that culminated in the creation of the Clover Park School District in 1941. Mann retired in 1948. Iva Alice Mann Middle School was dedicated in her honor on September 3, 1959. (Courtesy LHS, Cy Happy Collection.)

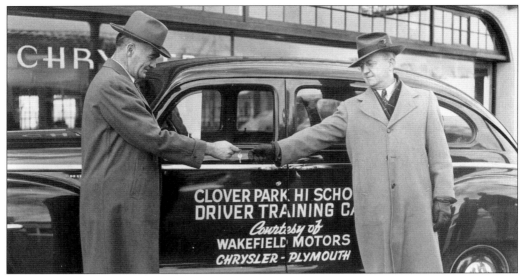

Superintendent of the Clover Park School District, Arthur G. Hudtloff, right, receives the donation of a car for repair as part of a vocational program. You could have a lively debate about who actually founded the city of Lakewood. But it can be said that by working to combine the various school districts into one cohesive district, Iva Alice Mann and Art Hudtloff are the mother and father of Lakewood. (Courtesy LHS.)

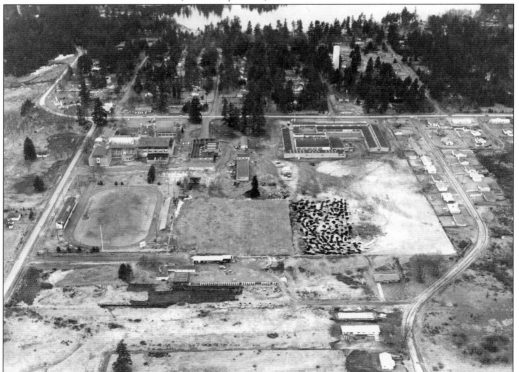

This aerial view of the Clover Park schools complex illustrates how Lakewood retained a rural feel—even in 1957. The population has since doubled to about 60,000. (Courtesy CP School District.)

Four

CLUSTERING AROUND
THE LAKES

No discussion about Lakewood would be complete without reference to the lakes. Each lake has its own history and character, while collectively they provided a key link that bound the community together. The lakes and waterways provided ready access to water for fields and farm animals, as well as quick and inexpensive recreation during the sunny summers and the freezing winters.

The largest of Lakewood's lakes is American Lake. It first bore the name Lake Tolmie, after the chief factor of nearby English Hudson's Bay Company post, Fort Nisqually. It was also called Richmond Lake, after the Methodist missionary who tried unsuccessfully to convert the local tribes in the 1830s. In 1841, it informally became American Lake after the first ever Independence Day party held north of the Columbia River and West of the Rocky Mountains happened along its shores.

In 1838, Lt. Charles Wilkes and his crew of 433 sailors left Norfolk, Virginia. His mission was to take the men and their six ships around the world and find trade routes to the Pacific Islands and China for U.S. whalers and merchants. This expedition was also charged with exploring the Pacific Coast. The government wanted to know if the English-held area had any value.

The crew shuttled around New Zealand and other South Pacific Islands before heading to the Pacific Northwest in 1841. The ships cruised up the Oregon Coast, naming geographic features along the way. On May 11, 1841, they reached Fort Nisqually. More sailing and naming filled the rest of May and June, before Wilkes returned to present-day DuPont in time for Independence Day, which fell on a Sunday that year.

Wilkes opted for a belated celebration the following day. As the sun came up, the party began with 26 cannon blasts, one for each state in the union. The gathering sailors climbed the banks of Sequalitchew Creek and paraded to Fort Nisqually. They gave three cheers to the British. The English gave cheers back, ignoring the idea that their American visitors were celebrating a holiday that marked their break from English rule. The parade continued as the sailors sang "Yankee Doodle Dandy" on their way to the nearby Methodist Episcopal mission. The seven Americans there made up the entire American population north of the Columbia River. John P. Richmond, his wife, America, their three children, a schoolteacher by the name of Chloe Clark, and a priest named William Willson had been at the mission for about a year before Wilkes arrived. They would stay only one more year before heading back.

The missionaries joined the sailors for a picnic on a grassy spot chosen by their Nisqually guests—the patch between Sequalitchew Lake and another lake they called Spootsylth. The body of water is known today as American Lake. The partiers ate beef cooked by an amply tattooed Pacific Islander named John Sac. The sailors ran horse races across the prairie. Some played an early version of baseball, called cornerball. Temperatures reportedly reached well above 100 degrees.

Wilkes ordered another round of salutes. Muskets fired 26 shots into the air. The cannon fired without incident the first time, but not the second. Quarter gunner Daniel Whitehorn suffered a mangled hand, which doctors said should have be cut off to avoid infection. He refused. Other sailors carried him back to the ship. He was discharged from the military when the voyage reached the East.

The men were somewhat familiar with such scenes, and although the accident threw a gloom over the party, it did not last long, Wilkes wrote in his report that the partiers sang "My County 'Tis of Thee" and the "The Star Spangled Banner" before breaking into speeches about their great nation. Richmond led a prayer and then spoke of a new era.

"The future years will witness wonderful things in the settlement, the growth and the development of the United States, and especially of this coast," he said. "This growth may embrace the advance of our dominion to the frozen regions of the North and south to the narrow strip of land that separates us from the lower half of the American continent. In this new world, there is sure to arise one of the greatest nations of the earth."

The more hidden Lake Louise was once named Balch Lake after Lafayette Balch, the founder of the nearby town of Steilacoom. It was later named for Louise Hopping, whose husband, William P. Hopping, owned land on the lake in the 1920s. Another story suggests that Lakes District developer Jesse O. Thomas Jr. named the lake after a resort spot in Canada.

Gravelly Lake is circled by vacation homes and well-to-do estates of Tacoma's elite, as well as the public estate garden Lakewold, a tourist attraction. Pierce County historian Henry Sicade said the lake was called Cook-al-chy, or "pond lily," by the American Indians in the area. Anyone familiar with Lakewood soil knows how it got its current name.

Fort Steilacoom's Kautz wrote in his journal that what is now called Steilacoom Lake was known as Byrd Lake because the body of water was manmade. The Byrd Mill was created and with the damming of Chambers Creek, the water built up behind the dam and filled in the lowland marshes.

Historian Herbert Hunt wrote that the American Indian tribes called the lake land Wheatchee, loosely meaning "underhanded or deceitful," because the area was known to be the site of odd occurrences.

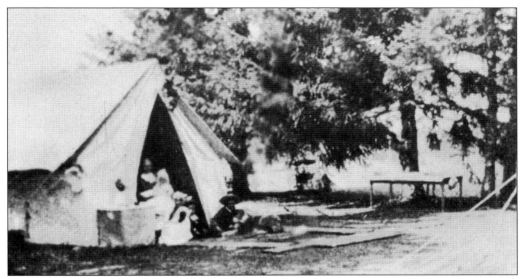

Along Gravelly Lake, around 1890, this Lakewood campsite of the Drum and Thompson families is among the first known photographs. Although Henry Drum was a staunch democrat and Walter J. Thompson a staunch republican (though he briefly ran for U.S. senator on the progressive ticket in 1916), they had something in common besides Jessie Thompson, wife and sister, respectively. Both men were prominent Masons and Tacoma bankers at the top of Tacoma society. After the financial panic of 1893, both men had to find other work. Drum received national attention in 1921, when he resigned as a prison warden rather than enforce the death penalty. Thompson's many businesses included the sale of homesites along Gravelly and Steilacoom Lakes. Thompson donated the initial $1,000 that allowed construction of the Clover Park athletic field, which is now Harry Lang Memorial Field, in honor of a former teacher, superintendent, and school board member who served the district for a record-breaking 60 years. (Courtesy LHS, Cy Happy Collection.)

A girl waits along old Pacific Highway about 1900 for the trolley to Stadium High School in Tacoma. (Courtesy LHS, Cy Happy Collection.)

As described on page 26, Albert A. Silcox was a key figure in development around American Lake. This is a scene repeated throughout what became known as the Lakes District—a family campground. Silcox worked for the Tacoma Land Company, and, in 1905, he bought the island for himself for $350. (Courtesy LHS, Family of A. A. Silcox Collection.)

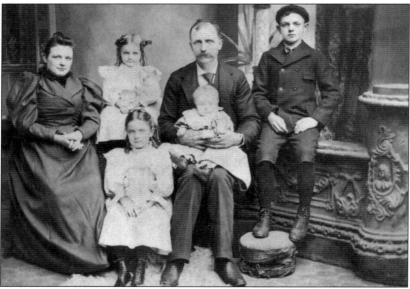

Pictured here is Silcox with his wife, Elizabeth "Betsy," and their children, Virginia and Bess (first row), and Fannie and Roy (second row). Silcox built a handful of vacation cabins out of scrap wood he ferried to the island. He used the cabins for visiting friends and the occasional paying guest. Dorothy Holm, Virginia's daughter, said, "We had just a wonderful time." Dorothy later married Clary Holm. They were involved in the first city incorporation efforts in the 1970s, and creation of the Lake City Community Center. (Courtesy LHS, Family of A. A. Silcox Collection.)

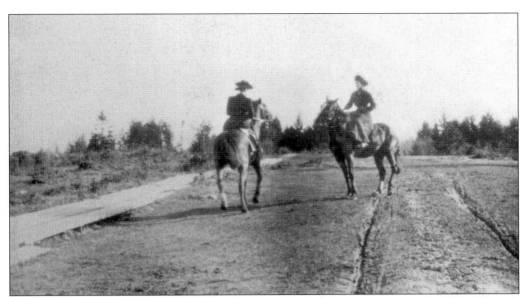

Two women, probably including Beulah Hyde, are pictured on a wagon road and buggy track next to a flume that ran from Spanaway Lake and South Tacoma Way to bring water to Tacoma. Beulah's husband, Robert Hyde, was president of the West Coast Grocery Company. (Courtesy LHS, Cy Happy Collection.)

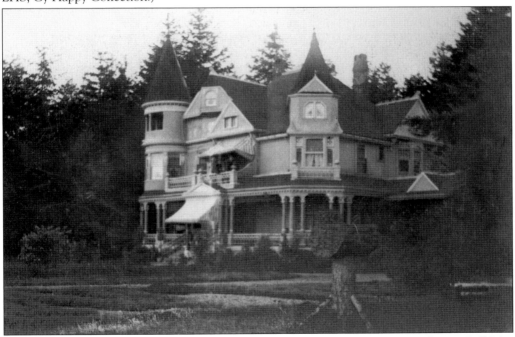

In the mid-1880s on a 40-acre site, Steven M. Nolan built the first prestigious home, Bell Mar Villa, on the shores of American Lake. The property was later sold to the Visitation Sisters for a school. The federal government bought the property in 1917 and built a veterans hospital, which remains on the property today. The late local historian Clary Holm wrote that Gen. Douglas MacArthur stayed here in 1904. (Courtesy LHS, Family of A. A. Silcox Collection.)

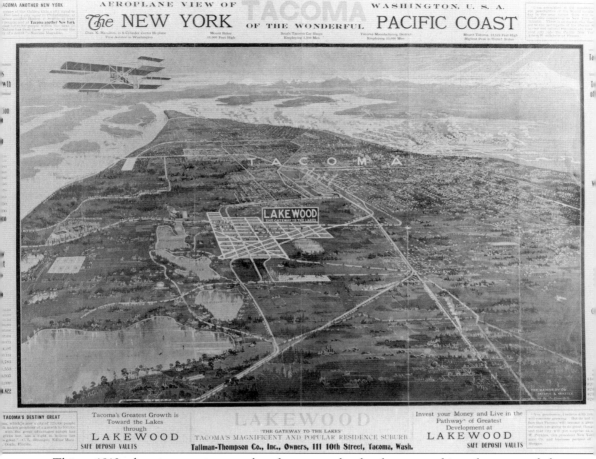

This *c.* 1910 advertisement is an early reference to the development taking place around the Lakes District. The aerial view of southern Tacoma shows a grid called Lakewood. (Courtesy TPL, G73.1-535.)

This *c.* 1912 photograph shows Gravelly Lake Drive, near Steilacoom Lake, the site of the Lakewood Mall and later Lakewood Town Centre. Though it is difficult to read the sign at the right, it does say Lakewood—one of the first photographic references to the name. (Courtesy LHS, Cy Happy Collection.)

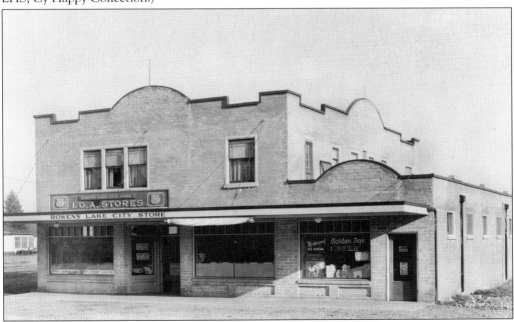

Rowen's Lake City Store, which is still around today, is pictured in 1935. The Rowens lived above the store. Lots in the area, which ran along a streetcar line, were offered in 1889, and a post office arrived soon after. Around 1907, the Pacific Traction Company built a track for electric cars from South Tacoma to Lake City. In 1922, a Veterans Administration hospital was built nearby. (Courtesy TPL RSC, M19-2.)

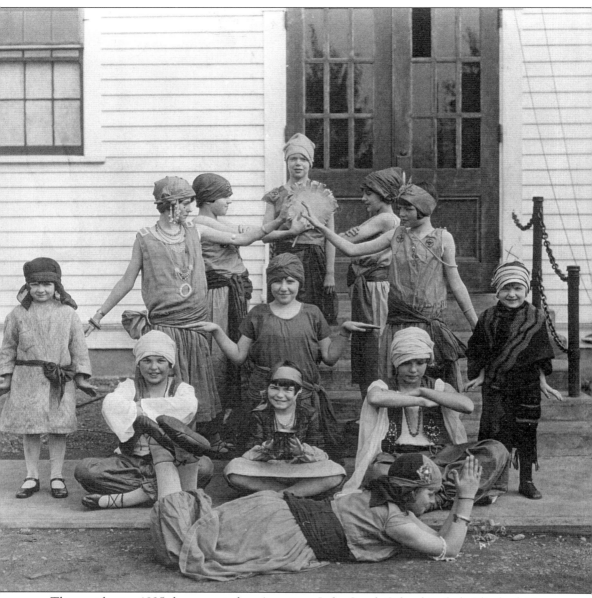

These girls at a 1925 dance recital at American Lake South School include Elizabeth Bona, Maxine Davies, Evelyn Hendricks, Eileen Madden, Janice Sears, Bernice Speakes, and Mary Ann Roth. (Courtesy LHS, Family of A. A. Silcox Collection.)

Five

TACOMA'S RICH
AND FAMOUS

Life in Lakewood for the upper crust of society meant wonderful privilege and leisure. The Lakes District was the Tacoma suburb that many of the City of Destiny's developers and tycoons chose to call home, even if it was only a summer one.

There were dinners at "the club," Tacoma Country and Golf Club, which is the oldest private club of its kind in the region. There were biking trips to Tacoma and Olympia, horseback riding through the open prairies, sailboat outings around the lakes, and picnics on the water. Money brought opportunity and possibilities and left behind some wonderful souvenirs in the form of buildings and memories.

High among those ranks was Chester Thorne, a New York Quaker–turned–railroad baron. In 1884, Thorne graduated from Yale and went to work for a railroad company. Glowing reviews from family members about Tacoma's potential brought Thorne and his wife to the area in 1890. He shuttled from Tacoma to Europe on financial trips through the next few years. The Depression of 1893 hit Tacoma and forced many banks out of business. He was president of the National Bank of Commerce in Tacoma at the time and raised $200,000 to save the bank by covering its deposits.

Thorne gradually piled up his fortune and built his dream house on what was then prairie land next to American Lake. Construction started in 1908 and took three years to complete. The year after he started building the house, which he named Thornewood, he owned three-fourths of the National Bank's stock.

The Tudor-style mansion included many features dismantled from a 15th-century English castle and shipped to the site on three ships Thorne commissioned specifically for the trip around Cape Horn.

Thorne entertained at the mansion with lavish parties for many of his social clubs and business friends. In 1927, his death, after a long illness, made the front pages of newspapers. Ships in the Pacific Steamer Ship Company fleet were ordered to fly their flags at half staff. Thorne was the vice president of the company at the time. The list of pallbearers at his funeral read like a who's who of Tacoma's history, including J. F. Weyerhaeuser and William Rust. The house stayed in the family for another 50 years. In 1982, historians added Thornewood to the National Register of Historic Places. It now operates as a bed and breakfast.

The country club also remains open. In 1894, young businessman Alexander Baillie felt he could cure the loneliness of his Scottish coworkers by recreating a game from home. The Tacoma Country and Golf Club was originally located in South Tacoma, but the club relocated in 1905 to American Lake after purchasing a seven-acre farm for $4,500. The club had the same problems as English pioneer Joseph Heath, in that it had difficulty growing its crop over the Lakewood gravel—in this case, grass.

One of the best-known reminders of the bygone era is Lakewold, a mansion and estate garden on Gravelly Lake.

In 1908, the widowed Emma Alexander was looking for a home when she purchased lot No. 23 in Interlaaken, near a streetcar line. It was the start of something big. By 1913, the gardens were featured in a newspaper story titled "Nature-loving Tacomans Make Modern Arcady of Gravelly Lake's Shores."

In 1918, Emma's son, Hubbard Foster Alexander, and his wife, Ruth Caldwell Alexander, took over the property. Alexander was president of Admiral Lines, for a time the largest shipping operation on the Pacific Coast. He and Ruth added property for a total of 10 acres.

The next owners, Everett and Mary Griggs, named the property Lakewold and later passed it on to nephew Corydon Wagner. His widow, Eulalie, stipulated before her death that Lakewold was to be cared for and preserved by a nonprofit organization. The estate is now the frequent scene of special events, including outdoor concerts and weddings.

All the creature comforts and opportunities wealth brings didn't come without a price for Lakewood's social elite. The big trouble with having wealth is that everyone knows you have it—even people who would think nothing of it to gain a slice of that America pie illegally. A few of the wealthier families that stayed summers in Lakewood suffered a price. George Weyerhaeuser, for example, was taken at age nine while walking in Tacoma on May 24, 1935. Charles Hyde III's kidnapping occurred 30 years later, November 17, 1965. Both boys were released after the families paid the ransom demands. All of the kidnappers were caught.

Weyerhaeuser was walking from the Lowell School to Annie Wright Seminary to meet his sister for lunch. He was held for a week in Spokane before the $200,000 ransom was paid and he was released near Issaquah, where he walked to a farmhouse and hailed for help. The marked bills later led to the arrest and conviction of Harmon W. Waley, his wife, and William Dainard. Their sentences weighed into the decades.

Hyde's father was president of West Coast Grocery Company when Charles III was forced into an automobile while walking to school. His father paid the $45,000 and received the 13-year-old boy the same day.

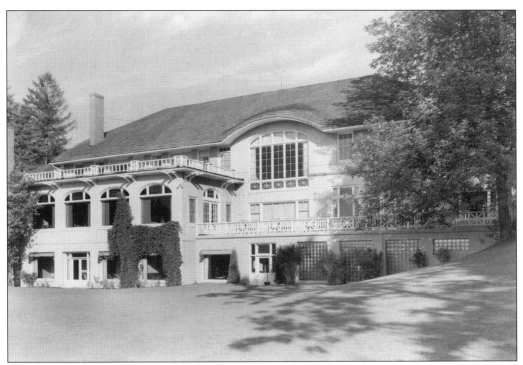

Pictured here in 1956, the "Grand Old Lady" was the clubhouse of the Tacoma Country and Golf Club, whose course and homesites sit on American Lake. The building, designed by the firm of Russell and Babcock, replaced the original rustic clubhouse that was destroyed by fire in 1909—a hint of the fate of this building. Perhaps its most famous feature was a huge spiral staircase that dominated the large entrance hall. (Courtesy TPL RSC, A101335-5.)

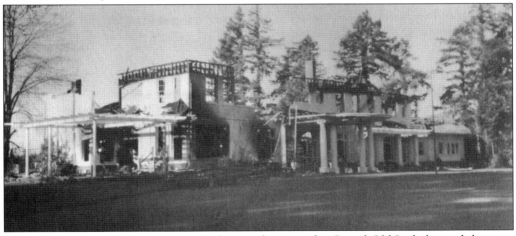

With what apparently began as sparks from a chimney, the Grand Old Lady burned down in 1961. The winds that day were high, and the heat was so intense that firefighters heard liquor bottles explode like grenades. The current building, also impressive, replaced this structure in 1965. Tacoma Country and Golf Club is the oldest continuing golf club west of the Mississippi. Its players have included Gen. Dwight Eisenhower, whose brother Ed lived nearby, Bing Crosby, and Babe Zaharis. (Courtesy LHS.)

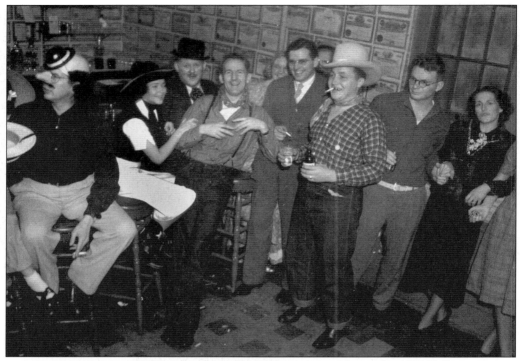

This is the 1937 Halloween barn dance at the country club. Besides the lively partiers, the most interesting feature of the bar is its wallpaper—stock certificates. The certificates represented about $8 million worth of investments that were ultimately worth . . . putting on a bar wall. Club president Harry K. Todd came up with the idea and donated many of the certificates himself. A park on the lake is named after Todd. (Courtesy TPL RSC, D1036-2.)

Alexander Baillie, who brought golf to the Northwest, is pictured here in 1948. He died the next year, two days short of his 90th birthday. (Courtesy TPL RSC, D35650-2.)

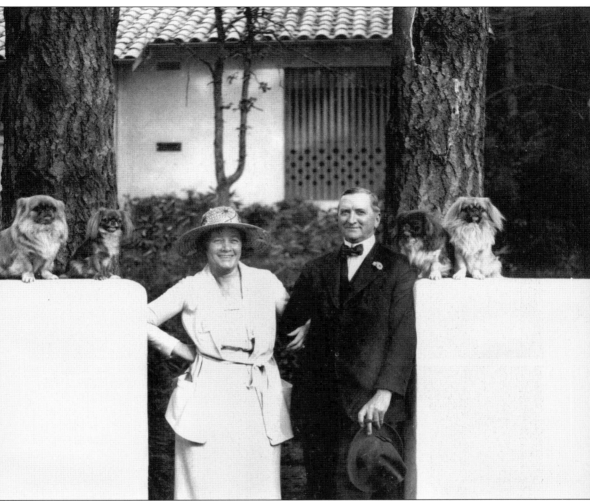

Joseph L. and Margaret Carman were the life of the party along Gravelly Lake and built the mansion Villa Carman, where they kept several Pekinese dogs. Joseph came to Tacoma in 1890 and established his mattress company, Carman Manufacturing. In 1919, the family bought land on Gravelly Lake, and one year later they began construction of the Italianate-influenced Villa Carman. Their son married Dorothy Alexander, a neighbor on the lake who is featured later in this chapter. The house and gardens were a popular social center until the couple died in 1938. The grounds were subdivided for housing in 1971. Actress Linda Evans owned the home later and recently sold it. (Courtesy LHS, Joseph L. Carman Family Collection.)

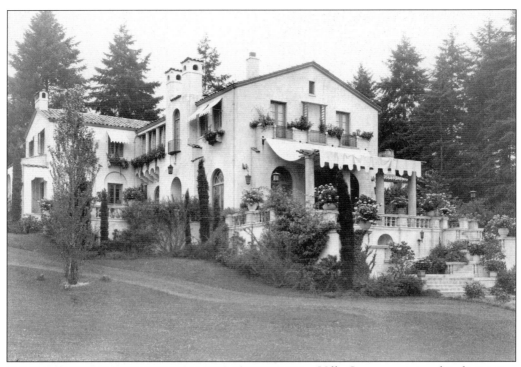

Villa Carman retains this distinctive appearance. (Courtesy LHS, Joseph L. Carman Family Collection.)

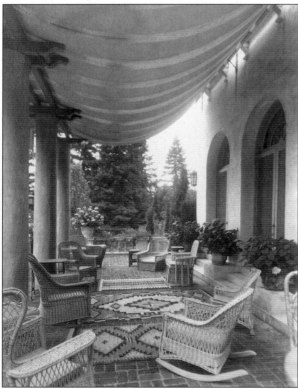

The porch of Villa Carman is pictured in the 1920s. (Courtesy LHS, Joseph L. Carman Family Collection.)

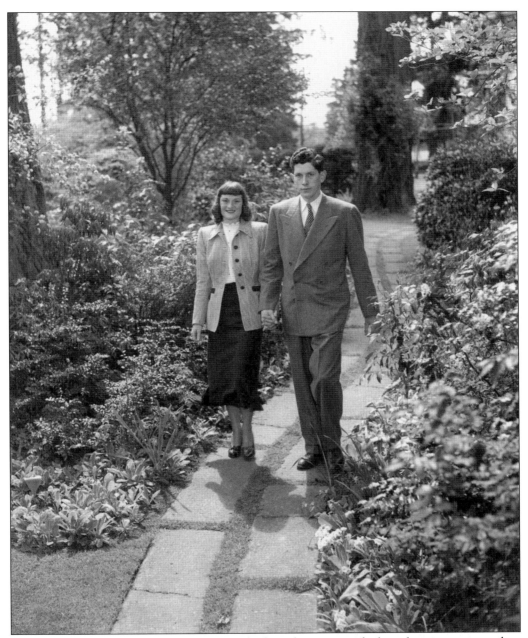

Joseph L. Carman III and Barbara Carman had just been married when this picture was taken outside Villa Carman in 1949. The Carmans honeymooned in Vancouver and Victoria, British Columbia. Before his recent death, Carman narrated a fascinating presentation for the Lakewood Historical Society in Villa Carman, complete with silent films of his parents and others. (Courtesy TPL RSC, D42208-1.)

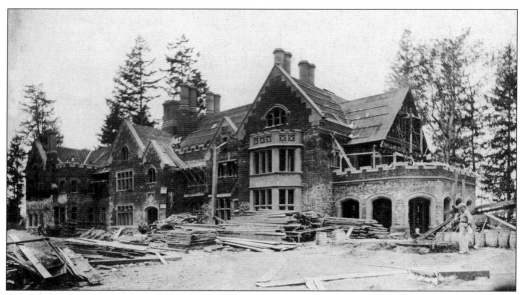

The Tudor Gothic mansion Thornewood is under construction in 1910 along American Lake. The building was meant to look like the old homes of England that Chester Thorne's wife, Anna, admired, but at the base of all that brick is concrete reinforced with steel. To please his wife, Thorne had the interior of a 15th-century castle shipped to Tacoma. The brick is from Wales. (Courtesy TPL, 4137.)

Unlike colleagues mentioned earlier, whose banks sank in 1893, Tacoma banker Chester Thorne raised $200,000 and kept The National Bank of Commerce open. After several name changes, it still services the Tacoma area as First Interstate Bank. Thorne was among the first to recognize that nearby Mount Rainier had tourist potential, and built lodgings there. (Courtesy LHS.)

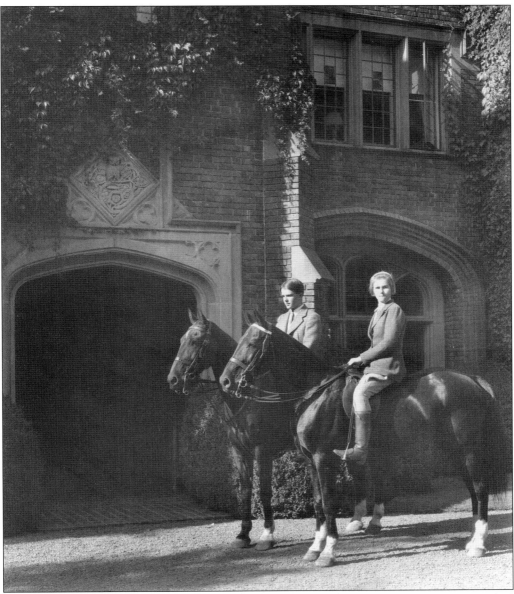

Thorne "Sandy" Corse and Nancy Corse, grandchildren of Chester Thorne, were photographed on horseback in 1936. Lakewood historian Cyrus Happy remembers archery tournaments outside the mansion on Saturday afternoons. He and other teenagers enjoyed the sport and company, but hated that they were required to dress very formally and wear hats. Chester Thorne died in 1927. In 1935, Anna deeded the property to her daughter, Anita Thorne Corse, who was known for wonderful parties. The estate gardens were later subdivided into homesites, though enough property remains for lovely weddings and other gatherings. The home has become a bed and breakfast and was the location for two films based on the works of Stephen King, including *Rose Red*. (Courtesy TPL RSC, H32-29098.)

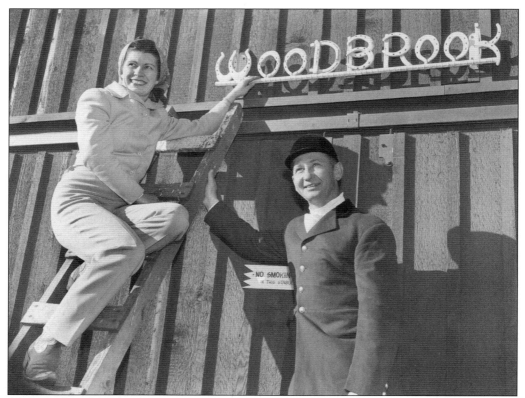

The Woodbrook Hunt Club remains in Lakewood as another example of how Tacomans and later local residents sought recreation in the area. Master of foxhounds Earl Craig and his wife, Leona, are seen preparing for the hunting season of 1951 in a barn that replaced one that burned in 1950. A small sign warns against smoking around the stables. (Courtesy TPL RSC, D61243-13.)

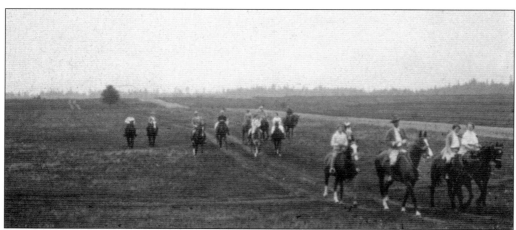

This mid-1930s photograph illustrates how empty the area's landscape could be. The Cyrus Happy family and others are riding from the Woodbrook Club along Old Pacific Highway toward Roy. The club sits on Lakewood's boundary with Fort Lewis. The tall man on the tall horse is Lee Dowd. (Courtesy LHS, Cy Happy Collection.)

Cyrus Happy's mother, Marjorie Sayre, a 1913 graduate from Stanford, bought five acres along Gravelly Lake and shared her "country" home with her aunt and uncle, the Todds. Marjorie's mother died of stomach cancer, and her father passed away before she finished college. He had not wanted her to leave school to visit him. About his mother, Cyrus says, "she came home an orphan." (Courtesy LHS, Cy Happy Collection.)

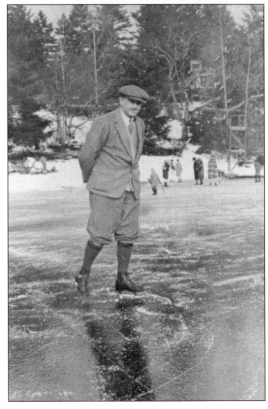

Happy's father, a corporate attorney also named Cyrus, is pictured on an iced-over Gravelly Lake in 1928. (Courtesy LHS, Cy Happy Collection.)

This is today's entrance of Lakewold estate, which attracts people interested in gardens and the lifestyles of the 20th century. The trees are much bigger now. Dorothy Alexander is riding a mule in this photograph. (Courtesy LHS, Joseph L. Carman Family Collection.)

Thelma was a pony who, along with her cart, was shared by many families. Dorothy Alexander is pictured at left with an unidentified companion. The tennis court is behind them. Thelma was eventually passed through about a dozen families as their children aged. The nursemaid usually served as the driver. Thelma knew to not stray too far from the house or run too fast, no matter how hard the children urged her on. (Courtesy LHS, Cy Happy Collection.)

The woman at left is probably Emma Alexander, to whom we owe the beginnings of Lakewold, with her granddaughter Dorothy and another girl. (Courtesy LHS, Joseph L. Carman Family Collection.)

Dorothy Alexander, the daughter of H. F. and Ruth Alexander, is pictured here across Gravelly Lake from the current entrance of Lakewold. Her father named ships after all of the Alexander women. (Courtesy LHS, Joseph L. Carman Family Collection.)

On her 16th birthday, around 1920, Dorothy poses outside the mansion with her new car. The black Chevrolet Cabriolet roadster had a red leather interior. Present-day Lakewold Gardens is an excellent example of the work of famed landscape architect Thomas Church, who preached that the garden should act as a large living and entertaining room. He regularly visited Lakewold between the 1950s and the 1970s. (Courtesy LHS, Joseph L. Carman Family Collection.)

This is another view of the lake and Dorothy, whose mother, Ruth, named the property "Inglewood." It later became known as Lakewold, Nordic for Lakewood. (Courtesy LHS, Joseph L. Carman Family Collection.)

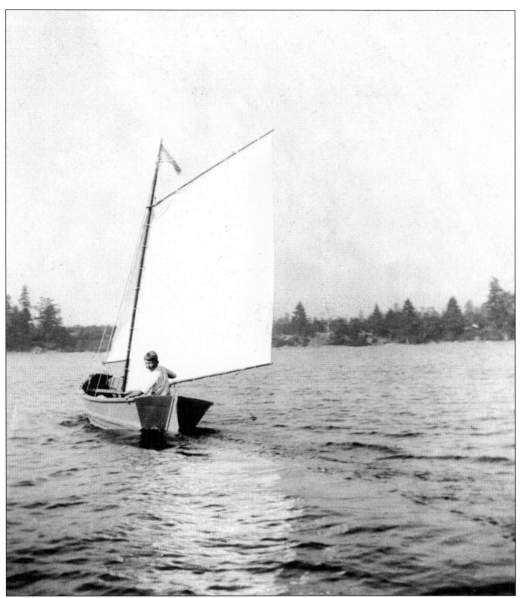

The exuberant youth boating on this Lakewood lake grew up to be one of Lakewood's most distinguished exports: Adm. James Russell. His father, Ambrose J. Russell, was one of Tacoma's most distinguished architects, proving that it was not just bankers who built summer homes around the lakes. At 1½ acres on American Lake, the home began as a sort of wood-framed, canvas-roofed tent that was later replaced by a cabin. James, born in 1903, attended Dekoven School. He began following around a charismatic, nautical man around the lake, a retired ships carpenter named Nordeen, and decided that he desperately wanted a boat. His mother, Loella Russell, made this sail herself on a hand-cranked sewing machine. James went on to distinguished and decorated service in World War II and the cold war years and became a naval aviation pioneer and four-star admiral, making him arguably American Lake's most distinguished "graduate." (Courtesy Peggy Bal.)

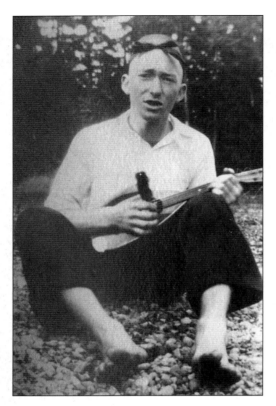

Because of the head start that Dekoven gave him, James Russell was 15 when he graduated from Stadium High School. He immediately tried to join the navy but was rejected because of his age. Russell then went on to join the merchant marine, and enrolled in the U.S. Naval Academy in 1922. (Courtesy Peggy Bal.)

James Russell and his older sister Margaret are on American Lake. The family owned one cow and rented another one named Violet. Nordeen taught James how to sail and how to milk a cow. Russell had fond memories of riding the then-empty Lakewood prairie on his horse. (Courtesy Peggy Bal.)

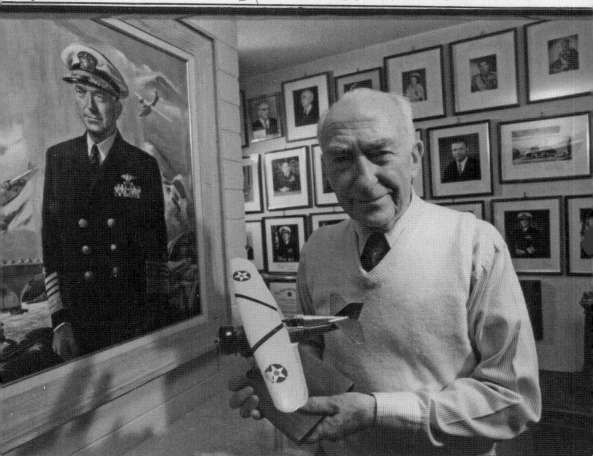

To my sister, Margaret, on her Nintieth — James S. Russell 3 September, 1989

Besides winning decorations for service in battle, Russell also won honors for diplomacy—he helped to negotiate treaties with Greece and Turkey and held awards from those countries, as well as France, Italy, Peru, and Brazil. Said Lakewood's first mayor, retired general Bill Harrison, to *The News Tribune*, "I never saw him when he wasn't spic and span, [and] doing and saying the right things." When Admiral Russell died at age 93 in 1996, the paper wrote, "In a career that began before World War II, Russell was a navy flier, a designer of aircraft carriers, commander of nuclear tests in the Marshall Islands and commander in chief of NATO forces in Southern Europe." He had invited veterans from Japan to his home. His son Donald told the newspaper for the obituary, "He reconciled with his enemies . . . It was extraordinarily important to him."

There's no question that the military has been the most influential employer in Lakewood, but the Weyerhaeuser Company is responsible for many current and retired staff who live in Lakewood. The Weyerhaeusers decided to move into "the country" during the 1940s. Both sons served in the military. Pictured here are John Philip "Phil" Weyerhaeuser Jr., Elizabeth Hunt "Wiz" Weyerhaeuser, George Hunt Weyerhaeuser, Helen Walker Weyerhaeuser, John Philip "Flip" Weyerhaeuser III, and Ann Weyerhaeuser. (Courtesy Weyerhaeuser Archives.)

After its dedication in 1938, the Little Church on the Prairie, seen here in 1941, became Lakewood's unofficial church of choice for many of the growing community's distinguished citizens. Norton Clapp purchased the combination grocery and hardware store, where people had purchased supplies for their summer camps, and at the urging of his wife, Mary, the daughter of a Presbyterian minister, turned it into a church with a steeple and new windows and doors. Mary and other residents met in the basement of the new Lakewood Theater to design the building so it would blend in with the colonial design of nearby buildings. John Philip Weyerhaeuser joined the board and personally designed benches for the sanctuary. (Courtesy TPL, Chapin Bowen Collection, TPL-1847.)

Six

WESTERN STATE HOSPITAL

When Fort Steilacoom was abandoned as a military post in 1868, the barracks were empty. The growing demands of the territory cried for a place to treat members of the community who suffered from mental ailments. The buildings and grounds shifted hands as the Washington Territory received the 640-acre fort and farm for use as an insane asylum. In 1870, the territorial legislature paid $850 for the 25 buildings. On August 19, 1871, the first patients moved into the former barracks. The hospital is one of the oldest governmental facilities in the state and predates statehood by almost a generation.

The lake in Lakewood's Fort Steilacoom Park is named after Dr. John Wesley Waughop, the superintendent of what was, before the turn of the last century, called the Washington State Hospital for the Insane. Waughop, a Scottish branch of the Wauchope clan, is pronounced "Wah-op."

Waughhop's road to immortality started in Tazewell, Illinois, where he was born on October 22, 1839. His schooling took a sideline when his college professor rallied volunteers to fight for the Union in the Civil War. He saw action in the battles of Shiloh and Vicksburg, working mostly as a surgeon's assistant. The medical equipment available at the time meant that he probably held a screaming soldier down while a doctor sawed off a limb or removed a bullet without administering any anesthetic. In 1862, he received an honorable discharge from service.

Waughop opened a private medical practice in White Cloud, Kansas, where he also served a stint as mayor. On February 1, 1866, he married Eliza Susan Rexford. In 1871, they moved to Olympia. In 1880, Waughop accepted the superintendent position of the state's only hospital for the mentally ill. Waughop managed the hospital for 16 years. He was interested in the new science of psychiatry during the early age of Sigmund Freud's theories.

Waughop and his wife are responsible for planting the rare trees, including an empress tree from China, located around the hospital grounds. The nearby lake was part of the hospital grounds at that time.

In August 1897, Waughop gave up the Northwest. He found his new home while on vacation in Hawaii.

In 1916, the 1,737-foot stone and mortar wall bordering Fort Steilacoom Park along Steilacoom Boulevard was built by patients and hospital employees.

The farm's most famous resident—certainly one for the history books—was Steilacoom Prilly Ormsby Blossom, a milk cow that produced 258,210 pounds of milk during her lifetime (1921–1938). The amount was a world record at the time.

Another notable landmark associated with hospital history is the now-ruined building in the center of Fort Steilacoom Park, built in 1932 to relieve the overcrowding at the main hospital complex. Poor heating and the long walk to the cafeteria doomed this "hospital on the hill" to be abandoned after only a few decades of service. It was left open to vandals for a few years, until blasters partially demolished it in 1992. Search-and-rescue crews from around the state use the rumpled building for evacuation training.

Fort Steilacoom Park has fields for soccer, softball, and baseball. The local high schools, sports groups, Pacific Lutheran University, the University of Puget Sound, and various groups and individuals enjoy the fields and cross-country paths. Walkers, bikers, runners, and kite fliers can also be readily found even during the worst of weather.

In 1971, Pierce College, then called Fort Steilacoom Community College, came to the former farmland turned hospital. In the late 1970s, the remaining hospital farmland became a county park. Some of the hospital buildings, including the barns, remain a legacy of the patient-run farm.

Two books were written about the land's history as a mental hospital—neither of them very flattering. Both books center around 1940s actress Frances Farmer's accounts of her time there, when she was forcibly committed for a mental evaluation, was abused, and was eventually given a lobotomy. Farmer eventually left the hospital and lived out the rest of her life as a chambermaid at a Seattle hotel. The two controversial books are *Will There Really be a Morning?*, Farmer's autobiography, and *Shadowland*, a biography written by a fan of the once up-and-coming star.

Not surprisingly, Western State is a highly regarded mental institution but is occasionally a place of controversy. The diseases of the mind are not simple ones.

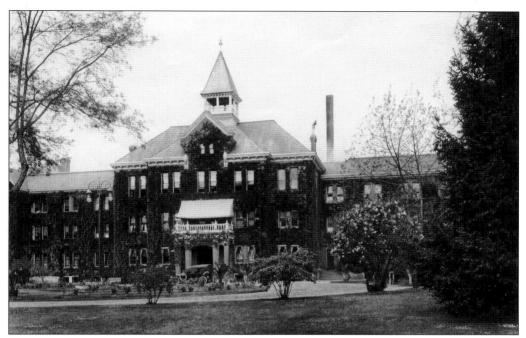

This main hospital building stood before the current one was constructed. Dr. John Waughop, who became superintendent in 1880, planted many of the rare trees that still line the hospital campus and nearby hillside. An archaeological dig found concentric rows and rows of bricks that had apparently been buried by patients undergoing some sort of outdoor bricklaying therapy. They also amended the gravelly soil with something that would retain moisture. (Courtesy HFSA.)

The hospital morgue, erected in 1907, is one of the oldest buildings on the grounds. (Courtesy HFSA.)

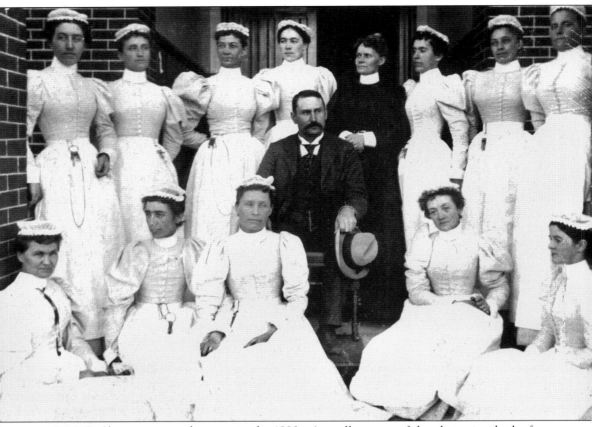

Dr. J. D. Shaver poses with nurses in the 1880s. A small portion of the plaster inside the former fort buildings survives despite weather damage during the 20th century. The interiors of the buildings were brightened considerably for inhabitants, with interesting designs and colorful paint. (Courtesy WSHHS.)

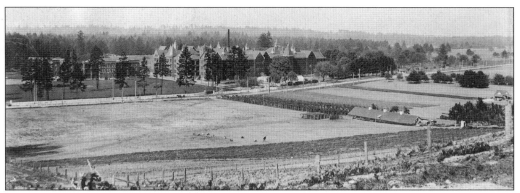

These buildings, pictured in 1916, were replaced in 1934. Farther past the hospital grounds, toward Chambers Creek, a golf course opened in 1951. The Oakbrook housing development began in 1963, with homes selling from $19,000 to $35,000, and, in 1967, the Oakbrook Golf and Country Club opened. (Courtesy WSHHS.)

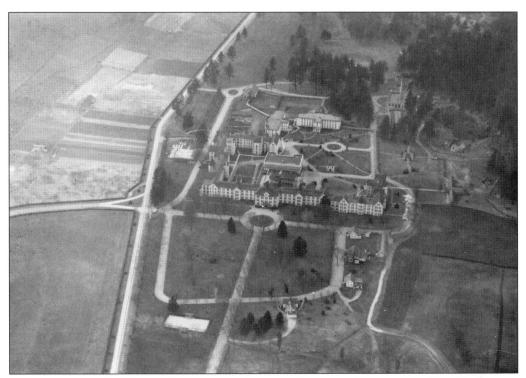

Another view of the Western State campus shows the four surviving cottages of Fort Steilacoom in the lower right. (Courtesy TPL G76.1-012.)

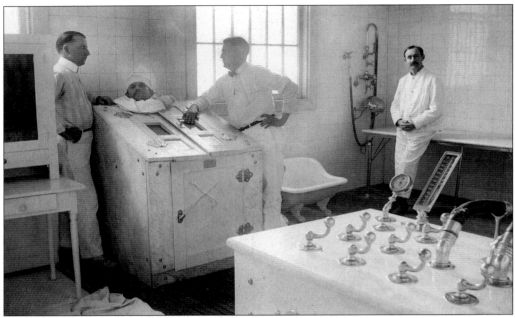

Considered a breakthrough in modern medicine, hydrotherapy (the use of warm water) marked an early movement in the treatment of the mentally ill—away from counseling and warehousing, to the use of drugs and biochemical remedies. Hypdrotherapy patients were prescribed floating or bathing for hours. The men in this 1920s photograph are unidentified. (Courtesy WSHHS.)

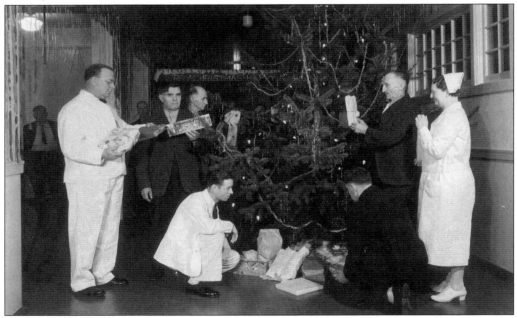

This photograph shows Christmas 1935 for some of the more than 2,300 patients at Western State Hospital. Mr. and Mrs. Ralph Mountford, in charge of the receiving ward, and attendant Oral King (kneeling on floor) help patients decorate the tree. More than 20,000 gifts arrived at the hospital from family members, friends, and charitable groups. (Courtesy TPL RSC, T54-2.)

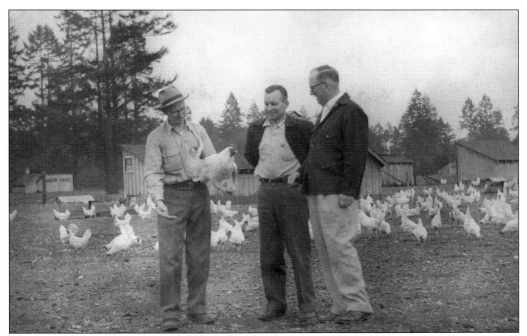

The poultry operation at Western State dates back to Dr. Waughop's time. The Western State staff is pictured here in the 1940s, with farm manager Leslie Arbuckle in the center. (Courtesy WSHHS.)

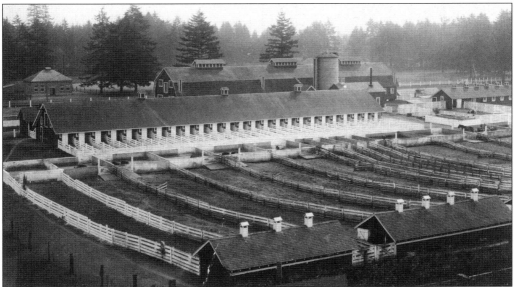

The open field near the hospital was used for growing vegetables and strawberries, and had a pen for chickens, pigs, and cows, and other essentials for mental patients between the 1900s and the 1960s. This land is now the sports fields and walking trails along Steilacoom Boulevard. The hospital farm provided patients with constructive activities, which was believed to help their mental therapy. At the turn of the century, sales of the farm's products helped cover a third of the cost of the hospital. (Courtesy WSHHS.)

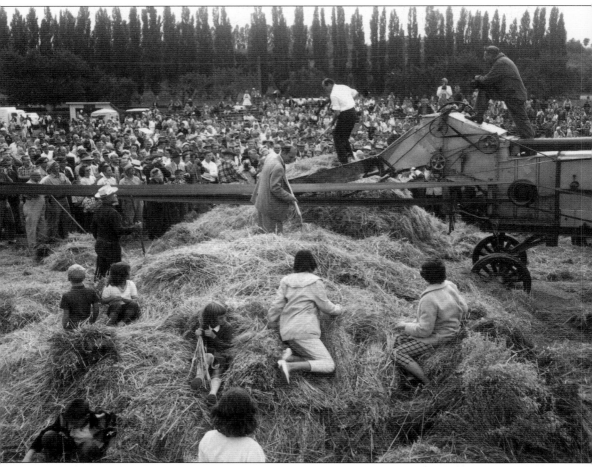

Washington governor Albert D. Rosellini was one of many community leaders at the Fort Steilacoom Old Fashioned Threshin' Bee on August 30, 1959. An estimated 13,000 people ate pancakes, watched steam-powered threshers, and rode a cable car around the 825-acre hospital. A plethora of straw and 196 bushels of oats were harvested. The hospital later closed the farm, and the grounds gradually became Fort Steilacoom Park, now a formal park and site of the annual community festival, SummerFest. (Courtesy TPL RSC, D122762-1.)

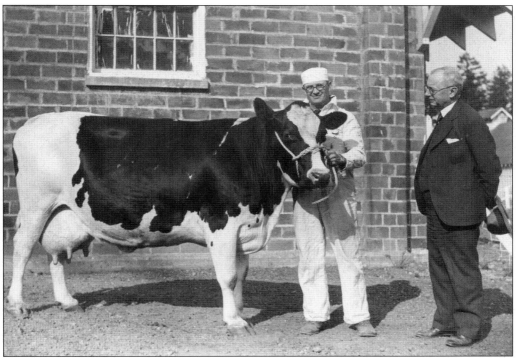

Western State's farm became well known for its cows, who won ribbons in many competitions. Steilacoom Prilly Blossom Sylvia II is pictured here in 1939 with A. D. Wertman (left), the farm director, and Dr. William Keller, hospital superintendent. The cow was the granddaughter of the famous Prilly Ormsby Blossom, who held the world's record for most milk production. From 1921 to 1938, she produced 258,210 pounds of milk and 9,556 pounds of butterfat. (Courtesy TPL RSC, D8275-4.)

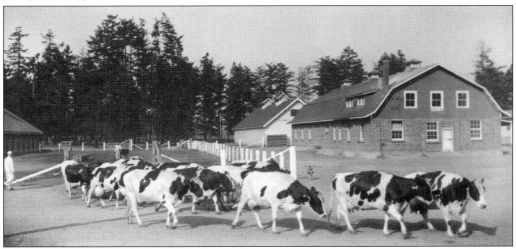

In 1939, Holstein dairy cows wander the Western State Hospital dairy farm at Steilacoom. There were more than 200 cows in the herd. Because of special measures taken early on with disease-infected cattle, the farm had been selective in breeding practices. Eventually the cows were known to produce more milk than any other herd in the United States. (Courtesy TPL RSC, 8275-1.)

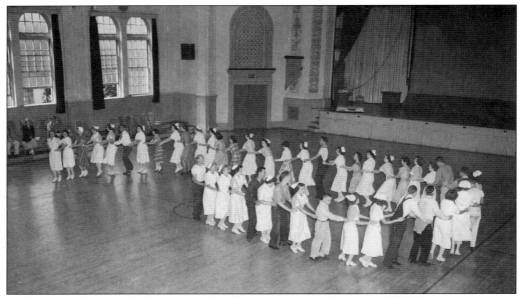

In this 1940s photograph, patients and staff enjoy a dance. (Courtesy WSHHS.)

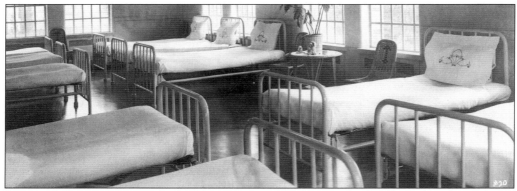

This is a typical 1948 hospital ward. (Courtesy WSHHS.)

One of the most famous patients in Western State Hospital history was movie star Frances Farmer, who was celebrated as another Greta Garbo when she rose to stardom during the 1930s and 1940s. William Arnold's 1978 biography of Farmer, *Shadowland*, told stories of Farmer facing abuse and indignity after her family sent her to the mental hospital for five years. Disputed by the hospital, *Shadowland* accounted that orderlies beat and abused Frances. Food was allegedly thrown on the floor for patients to fight over, and the criminally insane mixed with other patients, with predictably disastrous consequences. In 1957, Farmer staged a comeback of sorts. She starred in several movies and was even featured on the hit television show of the day, *This is Your Life*. Her appearance was a disaster. She had become a shadow of her former self. She abandoned attempts to regain her movie-star status. Farmer moved to Indianapolis, where she hosted the afternoon movie show for a local television station, and entered the ranks of Hollywood has-beens. NBC's *Today Show* profiled her life in 1964, but by then she was a broken woman. On August 1, 1970, she died of cancer at the age of 56. Poor, reclusive and largely forgotten, Farmer left her autobiography, *Will There Really be a Morning?*, to her friend to finish. Farmer's life became movie scenes in 1982, when Jessica Lange played her in *Frances*. Despite the controversy of various claims about the hospital, her story resonates with many people. Singer Kurt Cobain named his daughter after her and wrote a song about her. (Courtesy LHS.)

The 1,737-foot-long, stone-and-mortar wall running along Steilacoom Boulevard and bordering Fort Steilacoom Park was built by patients and hospital employees in 1916 and remains one of the most recognizable landmarks associated with the hospital. People tend to hit it a lot with their vehicles, as the fence is very close to the road. (Courtesy Steve Dunkelberger.)

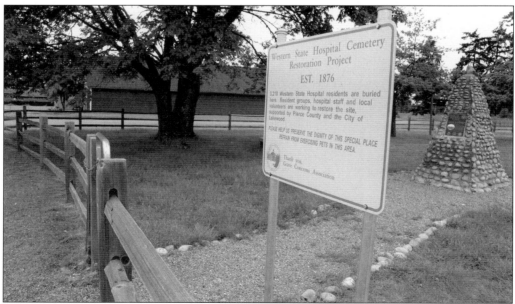

Several hospital employees, acting as volunteers, have recently beautified the former patient cemetery. Once in the middle of the farm, now in the middle of a park, the cemetery was in use from 1876 to 1953 and has more than 2,700 graves, most of which are marked only with numbers because of the perceived shame of mental illness. The volunteers are raising money to give names back to the dead with new headstones. (Courtesy Steve Dunkelberger.)

Seven

THE SPEEDWAY

Fom 1912 to 1922, Lakewood was in serious contention as the Indianapolis of the West. Nationally known racers joined locals in entertaining crowds at the Tacoma Speedway. "It was the most nationally known thing to happen to Lakewood, and now one knows about it," speedway historian Dr. Wayne Herstad says. "Everyone got into the act." The track opened in 1912, after a group of Tacoma businessmen led by Arthur Pitchard, president of the Tacoma Automobile Association, built a five-mile, all-dirt track. The track ran around what is now Lakeview Avenue, where the grandstands stood, to Steilacoom Boulevard and then to Gravelly Lake Drive and 112th Street. The first races were held on July 5 and 6, 1912.

"Terrible" Teddy Tetzlaff, a famous racer of the day, was set to headline the first race that year. He was kidnapped days before the race, however, and held for ransom—apparently in a Tacoma brothel.

The track changed quickly in those first few years. It shrunk to a three-and-a-half mile course in 1913, then to a two-mile track in 1914. The shorter course ran from roughly what is now Steilacoom Boulevard and Gravelly Lake Drive to 100th Street, then back to Lakeview.

In 1913 and 1914, famed racer Earl Cooper won at Tacoma Speedway. He came in second in 1915. Had he won that year, he would have been able to keep the revolving "Montamarathon" trophy with Mount Tacoma and racecars etched into its side. After his 1915 win, though, he was obligated to give it back for use in the next race.

In 1914, the grandstand shifted to Steilacoom Boulevard. In 1915, a split-board track replaced the dirt. The two-by-four planks were placed end to end, not flat on the ground, and had gaps between each board that were stuffed with gravel to save on lumber. The track used 15 tons of 20-penny nails and took 2 million board feet. The track corners were banked 18 feet to provide faster turns. But the track had constant problems with splinters, gravel shooting into cars behind the lead car, and popping tires.

There were countless race-related injuries to drivers and mechanics at Tacoma Speedway. The only fan fatality, however, befell a spectator in 1914 as he ran onto the track. He was struck while a car was going about 60 miles per hour during a pre-race warm up. The car was fixed and was ready to run by race time.

Two racing fatalities marred a 250-mile automobile race held at the Tacoma speedway on that first year with a wooden track, according to newspaper reports of the time. Billy "Coal Oil" Carlson

was fatally injured, and Paul Franzan, his mechanic, was instantly killed when a tire blowout on a steep curve hurled the car from the track on July 4, 1915.

Carlson was reportedly driving on used tires because he thought they would do better on the track than fresh ones. When the tire blew, it caused the rubber to be stripped from the wheel, and the rim caught in one of the ruts between the boards in the track. The open-air car didn't have seatbelts, and Franzan was tossed from the car and hit a stump. Carlson died the following day.

All the big names of the day raced around the Tacoma track. The cigar-smoking Barney Oldfield, who was the first racer ever to record a mile in a minute, left rubber on the course.

Unusual events at the course were typical. In 1916, a "fat man" race, where men over 200 pounds ran a 100-yard dash then sped around the track in cars, was held as well as a publicized grudge match between Tacoma and Seattle. The race organizers laid a mile of railroad track on the inside of the course and crashed two train engines together. The train representing Seattle stayed on the track and was deemed the winner.

Famed driver Eddie Rickenbacker dodged around cars in his Maxwell during a race in Tacoma on August 5, 1916, with a crowd of some 7,000 spectators. It was a disappointing turnout, since the grandstands were built to handle three times that number. The race spanned 300 miles, and Rickenbacker won. He later became known as the "Ace of Aces" for shooting down 25 German planes in World War I. Rickenbacker would return to the Tacoma track after the war to serve as a referee in 1919 and 1921. But the track did not pull in enough money, and 1922 was the last year of racing.

Pilots, meantime, found that the grassy oval inside the racetrack made for a great landing field. The site arguably is second only to Fort Steilacoom. After the speedway failed, the property became Mueller-Harkins Field, with its own many stories, then a naval base, and is now home to Clover Park Technical College. The conversion from speedway, to airfield, to naval institution was not without controversy. The local papers reported that Rudy Mueller did not want to sell his airport to the navy. The *Lakewood Log* thundered, "residents are literally waking up . . . to realize they live next door to a Navy Yard-Factory and their property values will be forever ruined."

The many thousands of people who have been and still are educated at Clover Park Technical College—and the many more who enjoy the rising property values of Lakewood—can safely say that things eventually worked out.

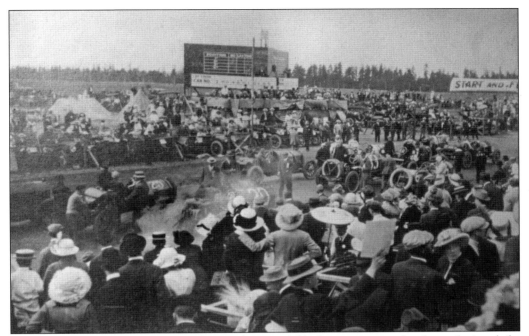

There are far fancier photographs of the speedway available, but most were taken by professionals for newspapers and away from the stands. In 1913, Cy Happy's mother caught this view from within the seating area, capturing the action and chaos of a race. (Courtesy LHS, Cy Happy Collection.)

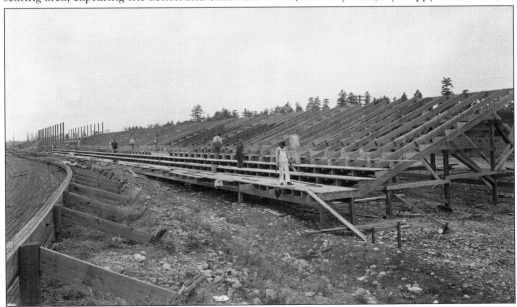

In 1920, the Tacoma Speedway grandstands had to be rebuilt, after an arsonist's fire burned most of them to the ground. The speedway did not have insurance, but backers raised $100,000 by selling bonds. The new stands would stretch a third of a mile and seat 15,000 people. This was the first time that some of the stands would be covered. There was room for 10,000 cars to park in the field. (Courtesy TPL, Marvin D. Boland Collection Series, G51.1-075.)

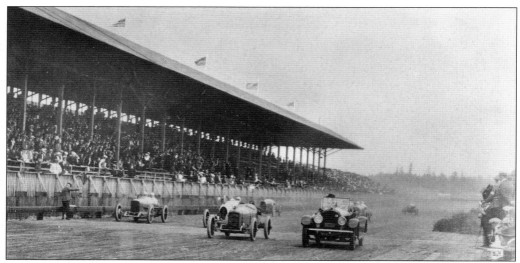

At 2:30 p.m. on July 4, 1921, the 10th-annual Tacoma Speedway Classic began. Nine drivers competed on Tacoma's infamous board track, very visible in this picture, for $25,000 in prize money. The pace car on the right, a Marmon Speedster, carries the referee—former race car driver and air ace Eddie Rickenbacker—and pacemaker Ray Harroun. The car on the left of the pace car is a Duesenberg driven by Roscoe Sarles, who had earned the pole position by driving 101 miles per hour during the trials. The race was won by Tommy Milton, who broke all speed records for distance with his average speed of 98 miles per hour. (Courtesy TPL, Marvin D. Boland Collection, G51.1-082.)

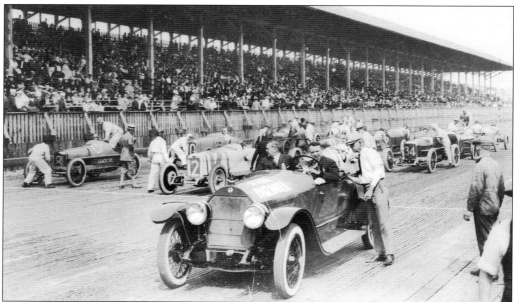

On July 4, 1922, 30,000 fans saw the last race held at the Tacoma Speedway. Ten drivers lined up behind the pace car, driven by Barney Oldfield, prior to the start of the 250-mile race. Jimmy Murphy, in his No. 25 Murphy Special, won with a record time of 2 hours, 33 minutes, and 55 seconds, with an average speed of 97.6 miles per hour. Tommy Milton in the No. 8 Leach Special, left, was only six seconds behind Murphy. (Courtesy TPL, Marvin D. Boland Collection, G51.1-066.)

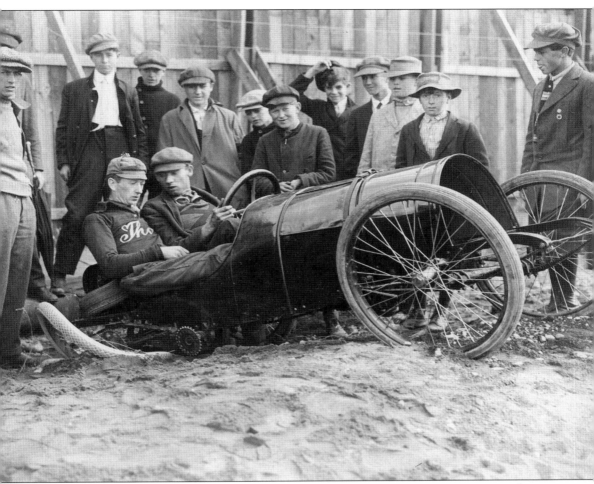

In September 1914, the Speedway hosted "baby" race cars that were piloted by juniors and run by motorcycle engines that could reach 35 to 50 miles per hour. As the boys practiced, they gradually increased their speeds on the muddy track. The Seattle Bug, driven by a boy known only as "Meagher," and his mechanic took a curve too quickly and slid in the mud, crushing both rear wheels. As the Tacoma Public Library caption notes, "The two seem at a loss as to where to go from here." (Courtesy TPL, Marvin D. Boland Collection, G52.1-010.)

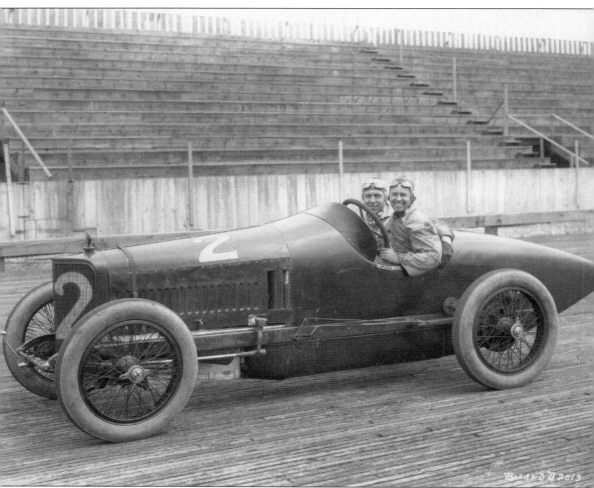

Ralph Mulford and his mechanic, Frank Eastman, sit in their Frontenac race car at the Tacoma Speedway in July 1919. Mulford was the lead car in an 80-mile race when engine problems forced him to drop out. The car was repaired, and he placed second in the 60-mile race and won the 40-mile race. Mulford had already been a national driving champion twice, even though he refused to race on the Sabbath. Mulford also had the distinction of being the driver to post the slowest time in Indianapolis—nine hours. In 1912, he was far behind when the winner crossed the line. When officials told Mulford that he still had to finish the race to receive his money, he decided to move slowly, and even stop for a chicken dinner. Mulford, born in 1884, survived the life of racing, set some records for mountain climbing, and died in 1973. (Courtesy TPL, Marvin D. Boland Collection, G51.1-115.)

Photographer Marvin D. Boland did not seem too worried about getting the full names of mechanics, as evidenced by the information written on this 1914 photograph of driver Grover Ruckstell and his mechanic "Quicksell." They came in second at the July 4, 1914, race at the speedway. Ruckstell was head of the famous Mercer racing team. (Courtesy TPL, Marvin D. Boland Collection, 068.)

Ralph Mulford, left, was one of the popular drivers at the Lakewood course. Driver Louis Chevrolet, right, pictured in Lakewood about 1919, would later admit to being a poor student in school but someone who loved to take things apart. The approach sure worked for automobiles, and his name lives on today with a company for which he was the original head designer. Louis himself won 27 major races. Chevrolet also formed his own company, Frontenac Motors, though it went out of business. (Left photograph courtesy TPL, Marvin D. Boland Collection, G52.1-027; right photograph courtesy TPL, Marvin D. Boland Collection, G52.1-031.)

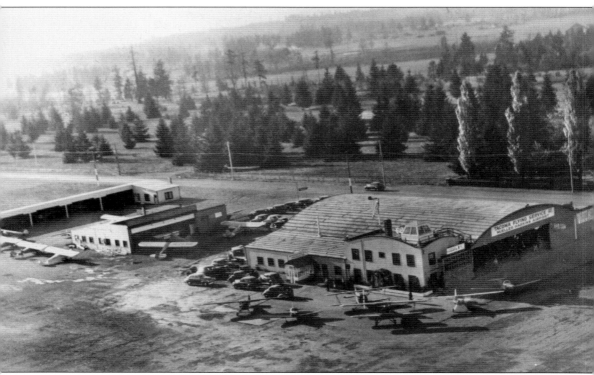

Until the City of Tacoma and the county built a field on the site of McChord, Mueller-Harkins Field was Tacoma's airport. In the 1930s, the Washington Air College was operated by George Fisher at the field. The navy used the property during World War II, and some of its buildings remain. The race tower became part of the airfield that is now Clover Park Technical College. (Courtesy LHS, Glen Spieth Collection.)

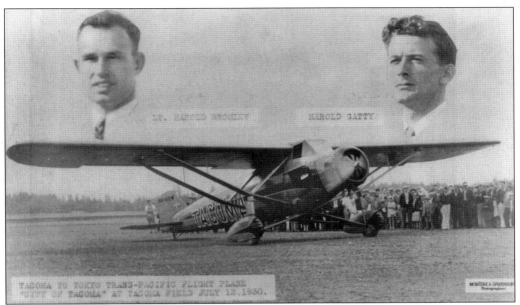

The repeated attempts of pilot Harold Bromley to fly the *City of Tacoma* to Japan are among the odder episodes of Lakewood aviation history. In 1929, Tacoma promoters offered $25,000 to anyone who could make the city famous as the starting point of a trans-Pacific flight. The plane could only carry a certain amount of fuel, so the idea on his first attempt was to give him a head start by going down a 60-foot-long ramp before beginning takeoff. But when the plane left the ramp, the bounce sent gasoline into the windshield and cockpit. Bromley was blinded, and the plane crashed. Bromley made several more attempts, including one with copilot Harold Gatty, but none succeeded. (Courtesy LHS, Glen Spieth Collection.)

Charlie, Bob, and Bill Hyde, sons of grocer Robert Hyde, watch as the *City of Tacoma* is readied. About 25,000 spectators witnessed the first of several unsuccessful attempts in ensuing months. Bromley's last effort was to fly with Gatty from Tokyo to Tacoma, to catch better winds, but they had to turn back—thus completing, as historian Murray Morgan wrote, "a roundtrip flight of Tokyo to Tokyo." The *News Tribune* writer Bart Ripp quoted Morgan as saying that Bromley had started out "as a hero and ended up a kind of civic joke. I think he was just a real unlucky guy." (Courtesy LHS, Cy Happy Collection.)

AIR CIRCUS
– and –
MOTORCYCLE EVENTS

Sunday
July 17

1938

Mueller-Harkins Airport

Sponsored by
Tacoma Young Men's Business Club

PLAY BALL WITH THE
TACOMA CITY LEAGUE
BASEBALL UNDER FLOODLIGHTS
EVERY NIGHT EXCEPT SUNDAY

| Lincoln Bowl | 7 o'clock | 36th & So. G Sts. |

A variety of events drew people to Mueller-Harkins Field. Besides air events, there were more eccentric stunts, such as a motorcyclist who crashed through a wall of burning boards. (Courtesy LHS, Dr. Wayne Herstad.)

– PROGRAM –

1:40 p. m.—Aircraft Race, 100 h. p. or under, 4 laps.

2:00 p. m.—Motorcycle Australian Pursuit Race.

2:10 p. m.—Naval Reserve formation flight over field.

2:20 p. m.—Aircraft Race, 45 h. p. or under, 3 laps.

2:40 p. m.—Motorcycle Tough Track Race, first heat.

2:55 p. m.—Women's Bomb Dropping Contest.

ARE YOU A MEMBER OF THE Y. M. B. C.?

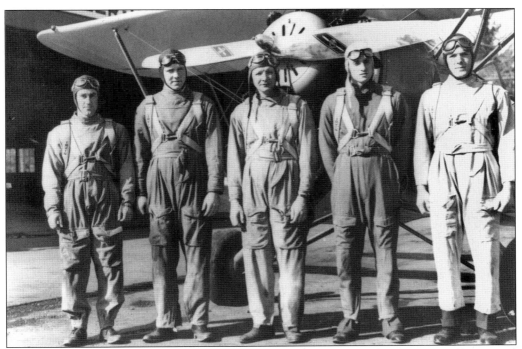

Before and during World War II, civilians could learn how to fly planes at the airfield. Pictured here, from left to right, are students Herbert G. Smiley, Arnold Ketler, instructor Ben Barry, Carl Smith, and Richard Bennett. Smiley and Smith were students at the College of Puget Sound, and Ketler and Bennett were students at Pacific Lutheran College. Both schools are now universities. (Courtesy LHS, Glen Spieth Collection.)

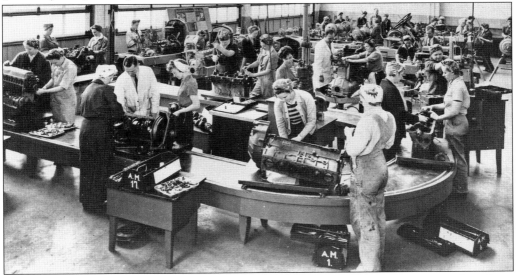

This is a 1941 "Rosie the Riveter" photograph. Clover Park offered small-engine and machine assembly to boys and girls as a way to boost the pool of potential workers for the war effort and provide a wide number of people with applicable job skills for the workforce. (Courtesy LHS, A. Hudtloff Collection.)

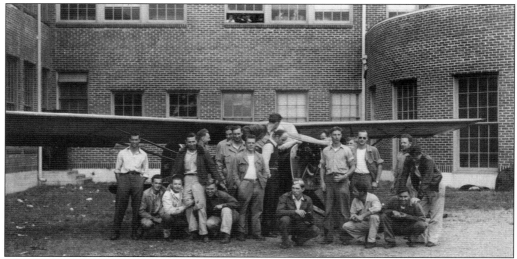

Fred Miner looks at an engine while aviation mechanic students pose at the back of the original Clover Park High School. This was the first airplane that was repaired and sold through what became a thriving aviation program. The program eventually moved to the former speedway grounds as part of Clover Park Technical College. Miner had enjoyed aviation since his youth in Nebraska and came to the area hoping to establish a public aviation mechanic school. Miner credited Iva Alice Mann for convincing him to locate within the Clover Park district. His expression here indicates that he may have found something wrong just before the photograph was taken. (Courtesy Clover Park Technical College.)

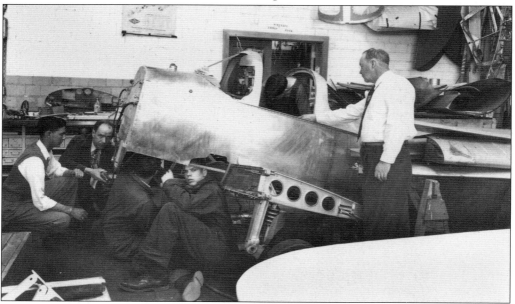

Miner, second from left, and instructor Arnold Cassidy help students repair a damaged ErCoupe. Three were repaired and sold to help support the training program. The aviation programs of Clover Park had moved to the grounds of what later became Clover Park Technical College. The complex eventually included a tower, so students could study air traffic control techniques. (Courtesy Clover Park Technical College.)

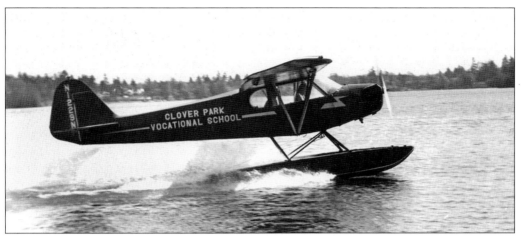

Seaplanes have been a common sight on American Lake. One of Clover Park's J-3 Piper Cub seaplanes takes off from the American Lake flight training center in 1953. (Courtesy Clover Park Technical College.)

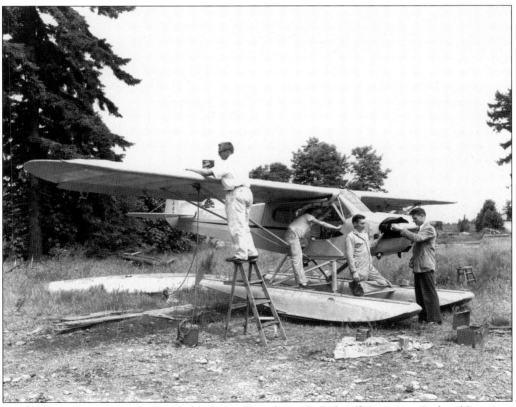

Instructor Dale Welfringer, right, helps students fix a J-3 Cub off American Lake. (Courtesy Clover Park Technical College.)

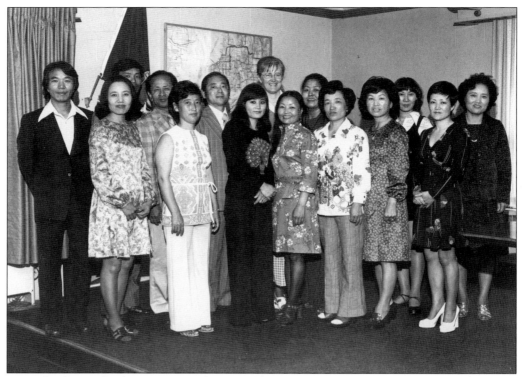

One of Lakewood's distinctions is that it is home to a high percentage of people of Korean heritage, who first came to the area via Fort Lewis and military marriages. Many other family members have followed. Clover Park Technical College began teaching English as a second language classes. In 1975, Lenore Bailey (second row, center) taught this class. (Courtesy Clover Park Technical College.)

The headquarters of Clover Park Technical College are seen here in 1979. (Courtesy Clover Park Technical College.)

Eight

MILITARY TIES

The residents of Pierce County, like the rest of the nation, knew war was coming and sought to support the nation with their own land. They voted to raise $2 million in bond money to buy up farmland east of Lakewood in 1917 and donate the 70,000 acres to the federal government for use as a military base. South Sound business owners knew such a fort would mean economic development for the area. Fort Steilacoom had proved that. Camp Lewis, named after Capt. Meriwether Lewis, was the first military installation to be created as the result of an outright gift of land by the citizens themselves. It remains the largest single gift ever given to the federal government. And it's a gift that keeps on giving, not only for the military, which got land for use as a major installation, but the area continues to get a stream of dollars flowing into the area in terms of paychecks for servicemen and government contracts.

Army-related spending at Fort Lewis alone tops $1.2 billion a year, not including the spending associated with the army hospital training center at Madigan Army Medical Center, McChord Air Force Base, the National Guard installation at Camp Murray, or the reserve units that operate from the area.

Madigan Army Medical Center, the massive medical facility at Fort Lewis, adds $225 million to the local economy through payroll and supply contracts. McChord Air Force Base contributes another $505 million. The national guard brings in $251 million. The army and air force reserve units in the area make up another $160 million in annual payroll. The total economic impact from the military is estimated at $8.5 billion each year in payroll, contracts, and secondary spending. Much of that directly benefits South Sound businesses. Not bad for $2 million worth of seed money.

Once the vote was cast in favor of the land gift, construction on the new fort began. On July 5, 1917, construction started, and 10,000 construction workers built 1,757 buildings and 422 other structures in three months. They also built streets, roads, and railroad spurs. When the buildings were completed, the workers pooled together $4,000 to build a stone gate that is still standing today.

The 91st "Wild West" Division trained at Camp Lewis before departing for France in June 1918. Many locations around the fort are named for Camp Lewis soldiers who died on the western front.

After the war ended, the base fell into disrepair, as military spending shrunk. Many residents felt they hadn't gotten their money's worth with their gift and demanded that the military return the land. Tempers fumed for 10 years, until Congress passed a building plan to renovate the structures. In 1927, the camp formally became a more permanent fort.

The post's population grew from 5,000 to 37,000 troops during the years leading up to America's entry into World War II. That's when the Fort Lewis north addition was constructed from a swath of what was open prairie south of the Lakes District. The fort served as a training facility to war-bound infantry soldiers as well as a holding facility for German prisoners of war.

When the war ended, there was a baby boom around the nation. That meant a housing boom as well. Lakewood, because of its proximity to a major transit base, saw an explosion of tract houses. Hundreds of inexpensively made, mass-produced houses sprung up around neighborhoods such as Lake City and American Lake. Many of those houses remain to this day.

Combat flared up again, and this time the battlefield was South Korea. Fort Lewis's 2nd Infantry Division was the first American division deployed to the Asian hot zone.

Fort Lewis expanded again when troops found themselves at the Puget Sound fort on their way to Vietnam. Fort Lewis became a training center for recruits, and a personnel center for processing soldiers to and from the South-East Asian combat zone. Some 2.5 million soldiers passed through the fort between 1966 and the summer of 1972, when Fort Lewis became the home of the 9th Infantry Division. Soldiers at the fort are now at the Department of Defense's post–cold war retraining efforts.

On July 3, 1940, McChord Air Force Base was formally dedicated in memory of Col. William C. McChord, chief of the Army Air Corps Training and Operations Division who was killed in a plane crash. McChord was instrumental in the development of the Alaskan air-defense system. Its airlift units provided air transport for personnel and equipment to northern radar sites. In 1950, McChord became part of the Air Defense Command's 25th Air Division, and provided air defense for the Northwestern United States. Fighter units were ordered to guard the air approaches to the nuclear plants at Hanford and other military installations. In the 1960s, the runway was lengthened to its current 10,100 feet. Airlift pilots began flying America's first all-jet transport, the C-141A Starlifter. The plane was replaced by the larger, faster, more modern Boeing C-17 Globemaster III.

It is this use of McChord as a cargo-shuttling hub that leads South Sound crews to find themselves in whatever military or relief operation of the day. Some of those missions included the following: presidential support flights into China and Russia, the return of United States prisoners of war from North Vietnam, and the positioning of United Nations peacekeeping forces around the world.

In a move related to the restructure of the air force, McChord's became the air defense hub of the entire western United States, from Texas, around the California coast, up through Washington, and all the way across North Dakota, doubling its area of responsibility.

As the closest civilian neighborhood edging Fort Lewis and McChord, Lakewood serves as a bedroom community for those soldiers who opt to live off base although some people move to other areas for reasons that are mysterious to the authors.

Fort Lewis is a choice position for soldiers, many of whom make the area their home when they retire from federal service. Some continue to serve their community through elected positions or leadership roles in business or organizations. Retired general Bill Harrison, who served as Fort Lewis's I Corps commander, later became Lakewood's first mayor. In the late 1990s, in fact, all the mayors of Lakewood, DuPont, and University Place were retired military. You might say that people in Lakewood can't spill their mocha without hitting the feet of someone connected to the military.

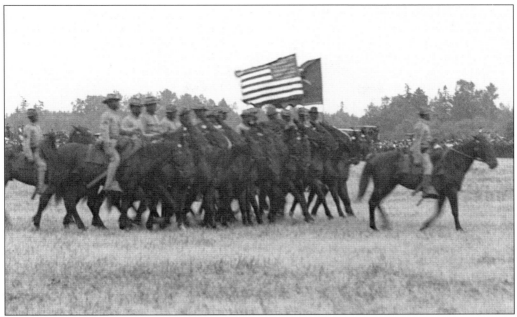

Even before Fort Lewis was officially formed, Lakewood had ties to the military. The army staged military exercises in 1904 around what is now Oakbrook and the Interlaaken area. The training that summer included these drills for an all-black unit of soldiers in what was than a segregated military. They were known as the Buffalo Soldiers. This is one of the first known photographs of African Americans in Lakewood. (Courtesy Fort Lewis Military Museum.)

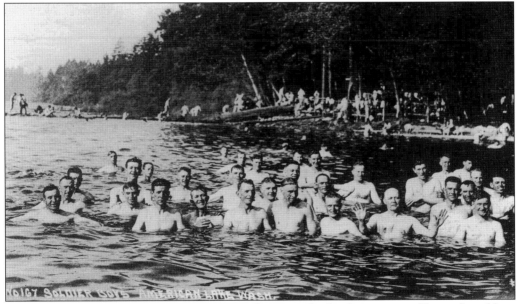

Opened at the dawn of World War I, Fort Lewis has proved to be the jumping-off point for soldiers bound for foreign service. The first soldiers into that conflict came from the base, and the first soldiers in harm's way today have local ties more often then not. They also recreate, as seen by these "boys" who are swimming. (Courtesy Dr. Wayne Herstad.)

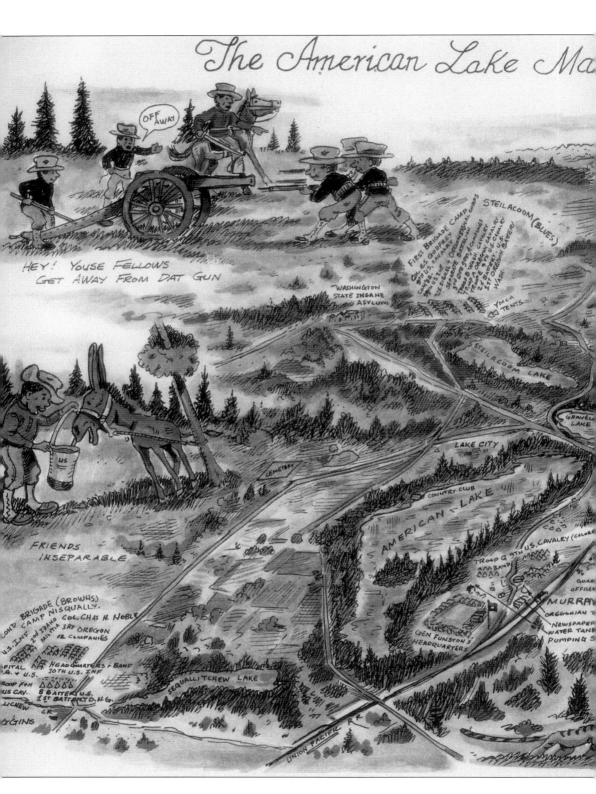

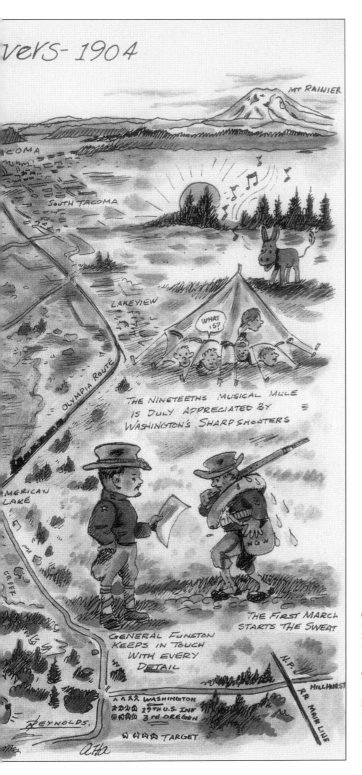

Curator of the Fort Lewis Military Museum and a noted author, historian Alan Archambault is also a well-known artist. He drew this illustration of the 1904 Buffalo Soldier training to give his modern-day visitors to the military museum a sense of the time and flavor of the army training that summer. (Courtesy FLMM.)

Medical treatment and procedures used during the 1904 training around Lakewood might seem crude by today's standards, but they included some of the best practices of the day. Keep in mind that these soldiers were only 40 years removed from the medical procedures used during the Civil War—when there was little understanding of bacteria and infection. Medical treatments involved little more than cotton bandages to control bleeding. (Courtesy FLMM.)

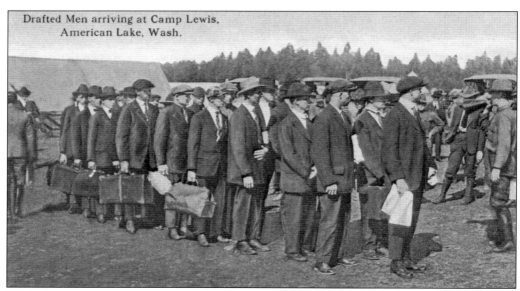

Drafted men arrive at Camp Lewis. (Courtesy LHS.)

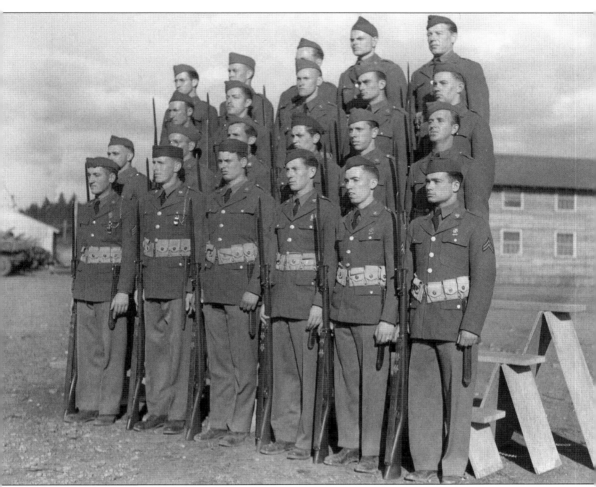

In this 1940s photograph, military police stand at attention, awaiting further instructions before heading to work guarding the gates and patrolling the "city" that was Fort Lewis. In what some consider a sign of the times, the MPs that once greeted people at the fort gates have largely been replaced with civilian contractors. (Courtesy FLMM.)

Anyone living around Fort Lewis during World War II could hear the sound of the bugler announcing revelry in the morning and taps at night. It is a practice that continues to this day—albeit through the use of a digital recording rather than an actual bugler, as was done in the 1940s. The entire fort's population stops whatever it's doing and stands at attention during taps, to mark the end of the work day with patriotic thoughts of the country they serve. (Courtesy FLMM.)

Nine

A Growing Sense
of Community

Just decades ago, a nurse who worked at Western State, a boy who lived in Lakeview and a girl who attended American Lake South would never have said they were in the same city. But the various attractions of Lakewood and the sprawl from Tacoma grew population over the years. In these pages, you will also see the effects of community visionary Norton Clapp and the post–World War II baby boom.

Cityhood was not approved until 1995. Without a central way of addressing community issues, people found their own solutions. Lakewood residents have a way of making things work. If a solution isn't readily available, they will find one and make it happen.

The history of the Lakewood Playhouse mimics the history of Lakewood, not only because of its central location, but because of its character. It was the heart of Lakewood long before there was a town center to put it in.

In 1938, more than two dozen people attended an acting class to put on a show. The list included a who's who of the Lakes District, including Harry Cain, Wade Perrow, Helen Chapman, and E. S. Cartozian, who served as the first president. The first meetings were held at the Little Church on the Prairie with performances taking place at the Lakewood Theater in Clapp's Colonial Center.

That first year, the group performed *Boy Meets Girl*, *When Ladies Meet* and *Yes, My Darling Daughter*.

The Lakewood Community Players, as they were known then, won critical acclaim from the press of that day. The *Lakewood Log* called them "a cultural asset." Shows were dinner theater back then, with lavish menus drawing as many crowds as the plays themselves.

Shows dropped off to only five productions during the war years. The group organized and performed five shows in 1946, in what was called the York room of the Lakewood Terrace restaurant in the Colonial Center and in available spaces around the area.

The group then sought a stage of its own. Plans came and went during the late 1940s and 1950s. Plans for the current theater's location began in 1962, when the owners of the Villa Plaza Development Company donated the land near what is now the Pierce Transit Center. The lease was signed in 1965. The almost-30-year-old theater finally had a home of its own. It had produced 93 shows in donated spaces and meeting halls.

In 1990, the theater finally hired its first full-time employee. John Olive served as the theater's artistic director and go-to guy and brought the theater to another level. His first show was *Steel Magnolias*. He served for six years, followed by Seattle theater directors Run Vzel and Ray Jarol. Then came Marcus Walker, who leapfrogged the theater into a regional standing today that the founders would find inspiring.

Newspapers had a bit to do with the creation and promotion of that community mindedness as well. And it all started with a contest in 1937—the same year that Clapp opened the Colonial Center as a magnet for community.

Charles Mann offered $10 to anyone who would name the newspaper of "rural journalism" he wanted to start in Lakewood. The losing entries included the *Prairie Gazette*, *Lakewood Bugle*, and the *District Honk*. The winner was the *Lakewood Log*—as in a ship's log.

The four-page edition came off the presses in August. For a $2 subscription, readers could be informed about every event in the area. Mann and his small army of society editors and neighborly columnists printed their home phone numbers in each edition for people to call in their family news.

Readers also were entertained by Mann's anything-goes editorials. "Speaking of hoarding, we observed the asinine shortsightedness of local citizens who are busily hoarding sugar they don't need, tires they won't need for another year and all the rest," Mann wrote in 1942. "Restaurants will be installing slot machines to dispense 1¢ worth of sugar at a time if customers don't stop getting frantic." Mann continued his weekly newspaper until 1961, when the paper merged with the *Suburban Press* to become the *Tacoma Suburban Times*.

The *Suburban Times* provided local news for the next 20 years under the direction of David and Mary Lou Sclair. Information shifted to a new newspaper called the *Lakewood Press*, which published weekly editions between 1982 and 1988. The company changed to the *Lakewood Journal* in 1988. Walter Neary served as its editor between 1994 and 1997, the period when cityhood began. Steve Dunkelberger also began at the paper 1994 and was its editor when the owners closed the paper in 2002. Ed Kane went on to publish a monthly newspaper until 2004.

The list of groups that helped Lakewood "work and play" is endless and could not even begin to be included in this book. There's the Lakewood Chamber of Commerce, Rotary Club of Lakewood, Clover Park Rotary, Communities in Schools, VFW and American Legion, Kiwanis Club of Clover Park, Korean Women's Association, Lakewood First Lions, Lakewood Knights Lions, Lakewood United, Keep Lakewood Beautiful, neighborhood associations, Lakewood Elks, Lakewood Korean Lions, Lakewood's Promise, Safe Streets, the Lakewood Women in Business, and many, many others. Each has done its part to make the city better.

This illustration shows American Lake before the influx of people began. Many drawings or photographs taken of landscapes in the region attempt to make Mount Rainier look about 40 feet away. (Courtesy LHS, Cy Happy Collection.)

This cabin provided a rest stop on the bike route from Tacoma to Olympia, just east of Lakeview, as seen about 1890. The ladies taking a break here could enjoy ice cream for 10¢. (Courtesy LHS, Cy Happy Collection.)

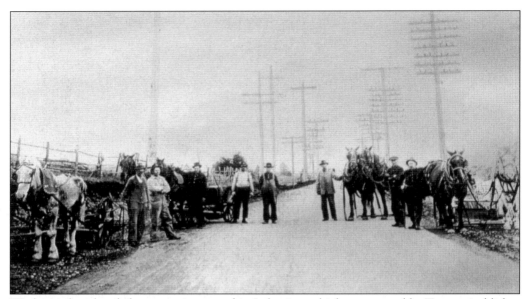

Workers take a break from creating a road in Lakeview, which was named by Tacoma publisher Thomas Prosch in 1876 for a small lake near the railroad stop. Both the station and the lake have since disappeared, though. A Sound Transit train commuter stop is planned for nearby. The lake was apparently connected with Steilacoom Lake by a creek. A post office operated from 1874 until 1963.

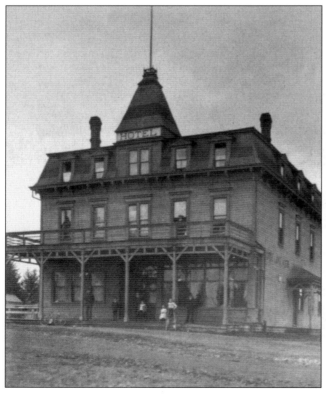

Among others, a boy on stilts poses in front of the Lakeview Hotel. The building is also visible on the next page (below the Tacoma speedway track on the upper right side of the aerial photograph).

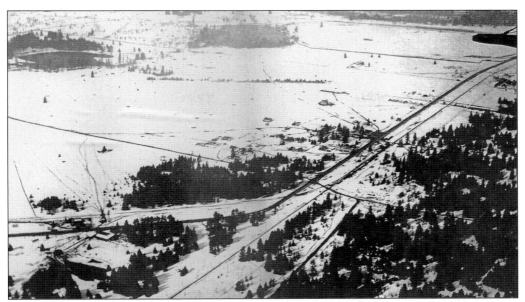

Lakeview, pictured here about 1920, owed its existence to the railroad. Running left to right is 112th Street. Settler Moses Ward started a post office here in 1874. A nearby lake and new city park by Interstate 5 and 84th Street are named for him. (Courtesy LHS, Cy Happy Collection.)

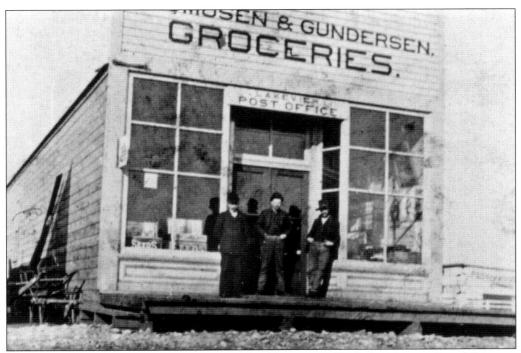

This is the Gundersen store in Lakeview. More buildings were added on in the area later. (Courtesy LHS, Cy Happy Collection.)

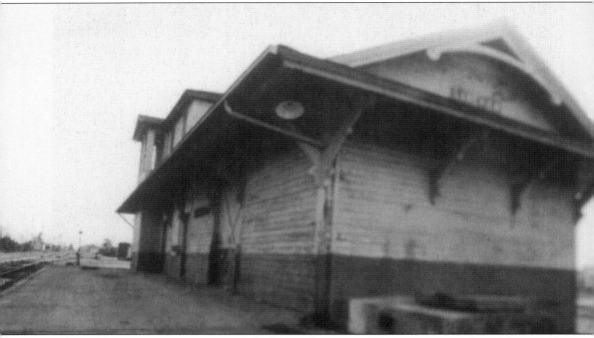

The Lakeview train station certainly had many happy moments in its history, but unfortunately, it was also the site of the racist mob violence against the Chinese that has come down through history as "The Tacoma Method." While many other communities blamed the Chinese for various problems in the 19th century, Tacoma actually expelled their immigrants. City officials had passed an order stating anyone of Chinese origin had to leave by the end of October 1885. About 150 Chinese men, women, and children left the area by the Halloween deadline in 1885. But things got violent for those who remained on November 3. In *Puget's Sound*, Tacoma historian Murray Morgan gives this account:

> They were herded and driven away like cattle. . . . The elderly and sick Chinese were permitted to ride. The rest trudged after the wagons, wrapped in blankets against the cold rain, duffels slung on poles over their backs. Their sandals sucked mud; some took them off and went barefoot. Many were crying.

Judge Thomas Burke witnessed the scene of the forced evacuation of the City of Destiny's Chinese population and recounted that night in a *Daily Seattle Post-Intelligencer* article three days later. "Three or four hundred armed men at Tacoma went around and packed up the Chinese, bag and baggage, and marched them through the streets and eight miles out to Lakeview, where they were left on the prairie all night, exposed, without shelter, to a drenching storm, and two died from exposure," he told the *Post-Intelligencer* reporter. "After the expulsion of the Chinese, their stores and houses were burned." To this day, Tacoma remains the only major West Coast city without a Chinatown. The City of Tacoma is now promoting a Chinese Reconciliation park along Tacoma's waterfront, not far from where a once-vibrant Asian community lived. By coincidence, the Lakewood land on which the Chinese suffered in the 19th century offers new hope to people of Asian heritage today. The neighborhood of the former Lakeview train forms Lakewood's International District as described on pages 120 and 121. The district has the largest concentration of Asian-owned businesses in Pierce County. (Courtesy LHS, Cy Happy Collection.)

Dr. Elizabeth Drake used this horse to get from place to place. Mr. Widdom cared for the horse, and it looks like he hopes the whole "car thing" does not catch on. (Courtesy LHS, Cy Happy Collection.)

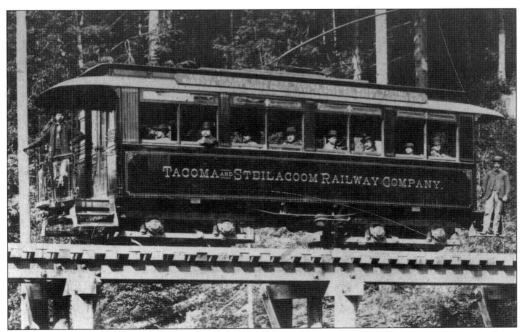

Trolleys were a popular and efficient form of transportation. This trolley carried people from American Lake to downtown Tacoma. (Courtesy Dr. Wayne Herstad.)

Ellen Freckleton would become a vital force in the Lakewood historical movement, but here she is simply a happy girl in a tree, pictured with some unidentified children. Freckleton, daughter of dairyman George Chapman, was born in 1902, and fulfilled a dream to see the new millennium before she died in 2001. Ellen was known as a very caring person; she delayed college plans for seven years to care for her grandmother after her mother died. (Courtesy LHS, Cy Happy Collection.)

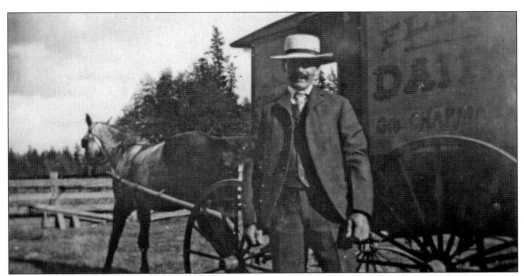

The Flett Dairy was named for John Flett, who first came to the Puget Sound Country from the Red River settlements in present-day Manitoba in 1841. The Hudson's Bay Company hoped Flett and others would counteract the growing influence of Americans in the area. Flett's name appeared throughout the early history of the area, as the name of a former stop on the street railway system south of Manitou and the name of the creek that drains that part of South Tacoma west of South Tacoma Way into Chambers Creek. Settler George Chapman came to the United States from Scotland and married one of Flett's daughters, Annie. Shortly after their only daughter, Ellen, was born in 1902, they began Flett Dairy with one cow. The dairy had 50 cows by the time he sold the business in 1910, Ellen Freckleton later said. Chapman also started a 14-cow dairy along Bridgeport Way to supply the nearby military Camp Lewis. After changing hands over several times during the passing the decades, the Flett Dairy finally closed its doors, for the last time, in 1994. (Courtesy LHS, Cy Happy Collection.)

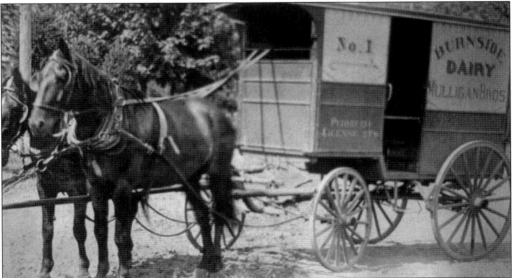

The Mulligan Brothers owned Burnside Dairy in the Flett area. (Courtesy LHS, Cy Happy Collection.)

While the railroad brought people to Lakeview, this Western Iron and Steel Company mill provided employment. Some people hoped the area would become a Pittsburgh of the West. The factory opened in 1885, and mill workers started moving nearby. The town of Lakeview was platted in 1890 by Levi Pentecost of Tacoma. The mill had closed by a few years later, though the community continued as a residential suburb tied by railroad and streetcar lines. A very attractive home nearby, on 108th Street Southwest, belonged to Judge Wilson, a superintendent of Western Steel. (Courtesy LHS, Cy Happy Collection.)

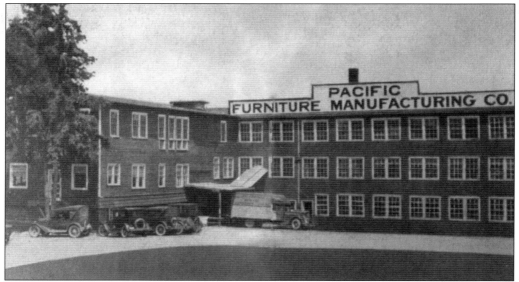

This factory, originally named Waterpower Furniture Manufacturing Company, was located near the site of the Byrd Mill. (Courtesy LHS, Cy Happy Collection.)

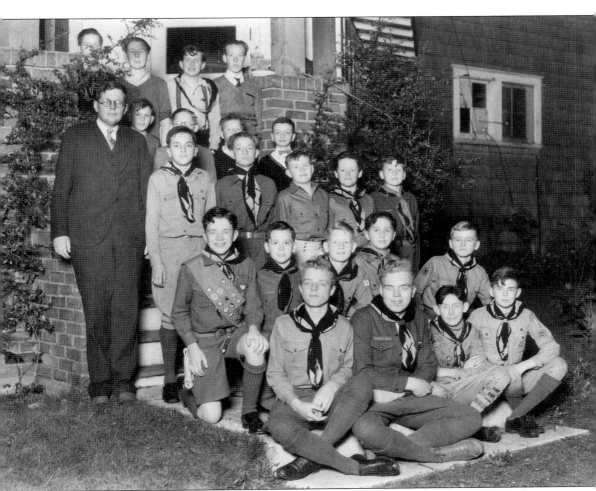

Community leader Norton Clapp is seen here in 1933 with Park Lodge School Boy Scout Troop 53, posed in front of Park Lodge. While Iva Alice Mann and Arthur Hudtloff helped shape community identity through the school district, Norton Clapp could be considered a father of Lakewood. The city would simply not be what it is today without him. Clapp built several prominent buildings and complexes that give Lakewood its identity today, such as the Lakewood Theater. He was involved in nearly all aspects of the community, saying at the time, "We are endeavoring to mold our little settlement into a self-determining community by designing its future cooperatively." He was also a national president of the Boys Scouts of America, served as a trustee for the University of Puget Sound, and was president of Weyerhaeuser Company. Clapp was one of the five original investors in Seattle's Space Needle. He died in 1995 at age 89. (Courtesy TPL RSC, 433-1.)

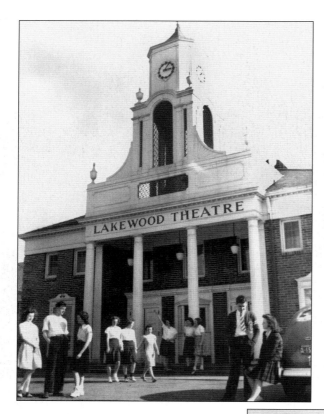

This photograph was taken for the 1941 Clover Park High School yearbook, showing students in front of what is surely one of Lakewood's most distinctive buildings, the Lakewood Theatre. Norton Clapp opened Lakewood Center, one of the first suburban shopping centers, in July 1937. The theater was a central hangout. After the movie, everyone went to Ludwig's Drug Store. Favorite orders were parfaits, sundaes, and ice cream sodas. (Courtesy TPL RSC, D10915-97.)

The Lakewood Theater has figured as the backdrop of countless photographs of Lakewood. Here the Mace sisters, Nancy (left) and Peggy, are likely on their way to or from the pecan rolls they remember from their visits here. (Courtesy Peggy Bal.)

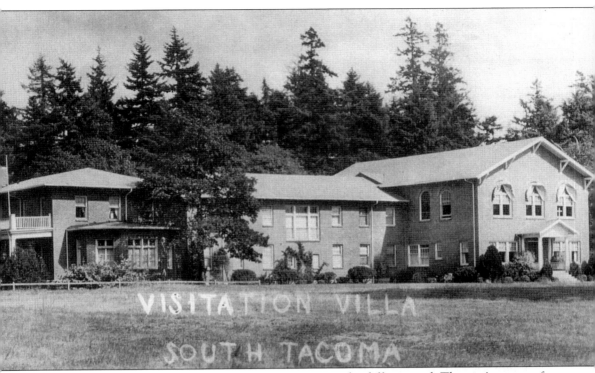

VISITATION VILLA
SOUTH TACOMA

The heart of Lakewood's church of commerce once praised a different god. The city's center of consumption worship was formerly a Catholic girls school. The Sisters of the Visitation operated a boarding and day school for girls and a summer retreat for women on 200 acres of the former donation land claim of A. J. Knight. Little is known about Knight, whose name was also spelled Knecht, even though his claim is in the heart of Lakewood. They moved to the location in 1923. The school operated until 1954, when it was sold to commercial developers following a fire that gravely damaged the buildings. The Villa Plaza shopping center, then the covered Lakewood Mall, and now the Lakewood Towne Centre were built on part of the property. Villa Plaza shopping center opened in 1957. It once offered attractions ranging from J. C. Penney to Bob's Big Boy. The center added a two-screen movie theater in 1969. The first movie was *The April Fools*, starring Jack Lemmon. (Courtesy Peggy Bal.)

The Richards Studio regularly photographed May Day at Visitation Villa Academy. Here, in 1938, the girls display their parasols. (Courtesy TPL RSC, D7255-6.)

In 1936, the girls of Visitation Villa Academy danced around a maypole for May Day and performed flag drills, the customary games, and races. (Courtesy TPL RSC, D1402-9.)

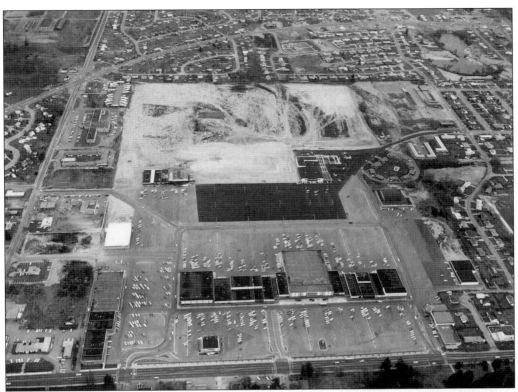

This large shopping center in the Lakewood area of Tacoma was named for Visitation Villa, a retreat for the Sisters of Visitation, who operated a school in South Tacoma and a day and boarding school at the Villa. The Villa was formerly an estate on Ponce de Leon Creek that was taken from part of the A. I. Knight Donation Land Claim. On April 12, 1988, owners of Villa Plaza announced that the name would be dropped totally by 1989, and in the interim the rebuilt shopping center would be known as "The Lakewood Mall at Villa Plaza." (Courtesy Peggy Bal.)

The Villa Plaza sign was a beacon for shoppers in 1957. The parking lot had space for 4,000 cars, meaning that there was plenty of room for parking. Stores included Mode O' Day, Woolworth's, Fashion Shoes, Weisfield's and Thriftway supermarket. (Courtesy TPL RSC, A94417-2.)

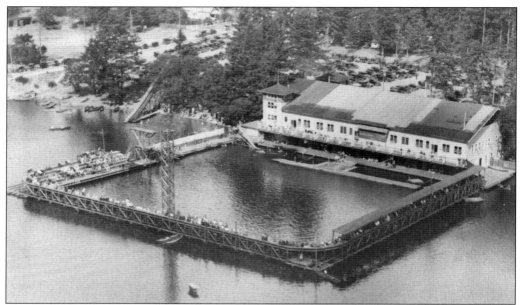

First there was the 3,000-person capacity Oakes Pavilion on Steilacoom Lake, also called the Silver Gray Towers after the large dance hall there. The Oakes was the place to be. At its peak, the Oakes hosted the swimming time trials for the 1924 Olympics. Norton Clapp purchased the facility in 1936 because his wife, Mary, enjoyed skating. He converted the building into the Swiss chalet–style home of the Lakewood Figure Skating Club. A number of distinguished skaters would "graduate" from the club, including Patsy Hamm and Jack Boyle. Judi and Jerry Fotheringill went to the U.S. Olympics in 1964. (Courtesy TPL, G54.1-157.)

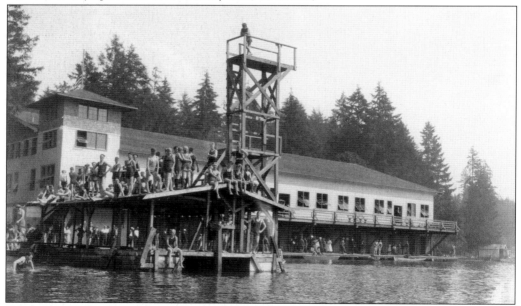

While the facility hosted dancing, dining and skating over the years, people also enjoyed the chance to swim at the northeast corner of Lake Steilacoom, relatively near the location of the Byrd Mill. (Courtesy TPL, G54.1-152.)

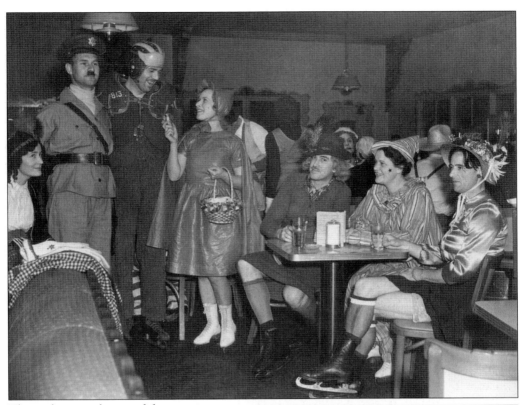

These photographs are of the interior of the Swiss chalet–style Lakewood Ice Arena. This 1939 masquerade, featuring a variety of costumed characters, shows people gathering in the café. The café was known for hamburgers, hot fudge sundaes, and lemon, lime, or chocolate colas. Hundreds of Lakewood's former youth have memories of first dates and other events here. (Courtesy TPL RSC, D8151-4.)

Marcella McGavick laughs as Lorne McKendry hits her husband Leo, dressed in prison garb, over the head during the 1939 party. Note the distinctive Swiss-mountain mural that remains etched in memories of the Lakewood Ice Arena. The arena met a sad fate: the roof and part of a wall collapsed in 1982. Condominiums were later built on the site and can glimpsed as people speed past on Steilacoom Boulevard. (Courtesy TPL RSC, D8151-24.)

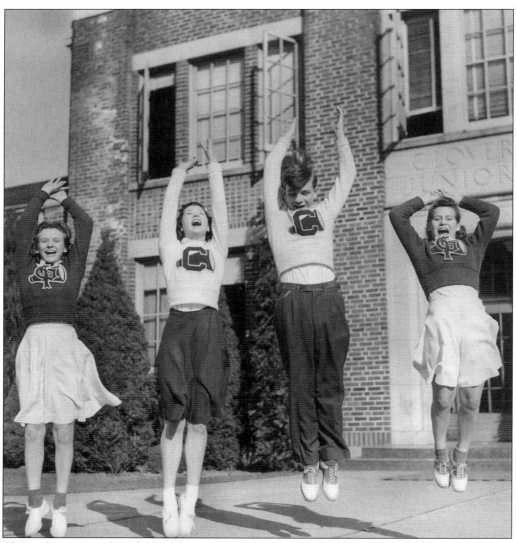

This is the picture of youthful exuberance in 1941: Cheerleaders, from left to right, Garnet Miller, Dorothy Witt, Merton Lee "Teen" Johnson, and Bebe Long show spirit for the 1941 Clover Park High School "Warriors." During this time, the school also educated the youth of University Place, Parkland, and Steilacoom, before those communities had their own schools and before the Clover Park district also built Lakes High School. Clover Park was for grades 7 through 12. After school, students headed for the Clover Patch Cafe, across Gravelly Lake Drive from the school entrance, where they ate hamburgers, drank milkshakes, and danced the jitterbug to '78 records on the jukebox. Smoking was prohibited within a half mile of the school. In the evenings or on Saturdays, the youth skated at the Lakewood Ice Arena on Steilacoom Lake, and with colder winters, often skated outdoors on frozen small lakes like Seeley Lake. Sock-hop dances after the school games saved the polished floors of the gym. The Clover Park building stood until 1981. A fire gutted the building so extensively that the school was demolished and a new facility was dedicated in the fall of 1982. (Courtesy TPL RSC, D10915-57.)

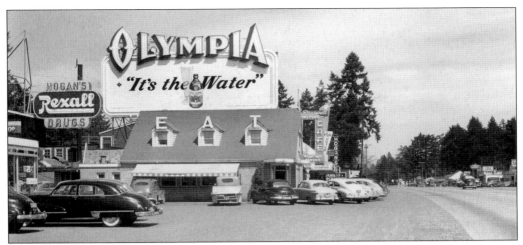

This is a 1949 view of a recently erected electric sign along the former state highway that runs past the Ingleside Cafe located on 12914 Pacific Highway SW. The Ponders area, named for Amos and Belle Ponder, has a long history. The area attracted businesses serving people traveling between Tacoma and Olympia and had a livery stable and saloon as well later as a depot for the Tacoma Railway and Power Company line. After this photograph was taken, the Ponders area attracted a somewhat disreputable name because of soldiers and others following pursuits of the flesh, but the area has cleaned up considerably since cityhood. (Courtesy TPL RSC, D42402-2.)

In many ways, this 1952 photograph of construction at Lakeview Village "frames" the recent history of Lakewood. Fueled by the World War II baby boom, the once-open prairies filled with activity—and homes. Subdivisions grew like the reeds in Lake Waughop, and hundreds of small houses that stressed number of rooms rather than size were built around central Lakewood and remain in use. (Courtesy TPL RSC, A67619-6.)

Lakewood originally received fire protection from the nearby military base, but that was not insufficient for a growing city. A few years after construction of the Colonial Center, voters approved a fire district in 1940. They acquired their first truck in 1942. The first fire station survives as the building for B&B Glass on Gravelly Lake Drive and 111th Street. (Courtesy Lakewood Fire Department.)

This photograph of new firefighters and pageant princesses was taken in the 1970s. Many of the firefighters in this picture still serve in Lakewood. (Courtesy Lakewood Fire Department.)

The Lakewood Water District was formed in 1943, following closely on the heels of the formation of the fire and school districts. Here several people watch in 1950 while William Elliott sets loose water from a new well that would serve approximately 10,000 people in what was then called the Lakes district. The onlookers are, from left to right, LeRoy Gunnarson, John Robinson, Fred Schwab, Mrs. L.R. Gaudio, J. Neudorfer, Merlin Gunnarson, Victor Nieman, B. C. Turner, and Wayne Cofer. (Courtesy TPL RSC, D53631-4.)

The first staff of independent Lakeview Power and Light, seen here in 1922, included William T. Jones, left, the general manager for 36 years. He then became a formal advisor to the utility until his death in 1958. "This was his life," says longtime board member Paul Russell. A group of farmers and others collected $500 to begin the utility. (Courtesy Lakeview Light and Power.)

To celebrate the third anniversary of Villa Plaza, the Washington State Fryer Association offered a 29¢ chicken feast on August 4, 1960. Two 60-foot barbecue pits were set up in front of the Woolworth and J. C. Penney section of the shopping center to barbecue thousands of chicken legs and thighs. (Courtesy TPL RSC, D127769-3.)

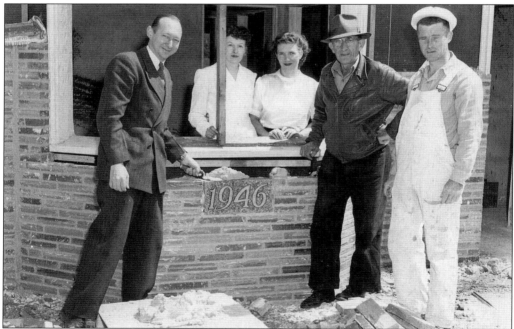

Before Dr. Lawrence Skinner, left, established the Lakewood Clinic, residents generally went to downtown Tacoma for care. Lakewood residents are now cared for locally at St. Clare Hospital, which is part of the Franciscan Health System. The nonprofit bought the former Lakewood General Hospital, which was located on what is now the Lakewood Pavilion shopping center at Lakewood Drive and 100th Streets. This photograph was taken at Skinner's first clinic, at 100th and Gravely Lake Drive. (Courtesy LHS.)

Lakewood's largest lakes, from top to bottom, are Steilacoom, Gravelly, and American—seen here from an altitude of 5,000 feet on a hazy April 1964 day. There are certainly fewer trees today. The short but scenic Interlaaken Bridge crosses the Steilacoom Lake to the left. Ponders and McChord Air Force Base are on the right. Tacoma Country and Golf Club is visible on the shore of American Lake. (Courtesy TPL RSC, D141601-12.)

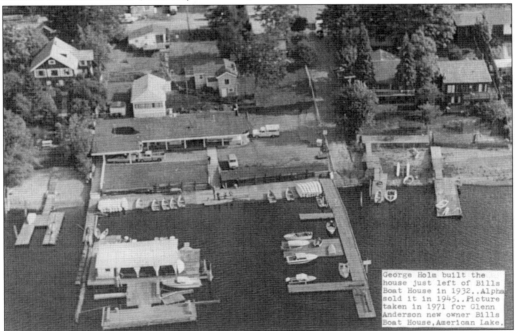

George Holm built the house just left of Bills Boat House in 1932..Alpha sold it in 1945..Picture taken in 1971 for Glenn Anderson new owner Bills Boat House,American Lake.

This is an aerial photograph taken in 1971 for Glenn Anderson, the new owner of Bill's Boathouse, a Tillicum institution. The boathouse, since improved, has remained in family ownership. (Courtesy LHS, family of A. A. Silcox Collection.)

The C. C. Mellinger Funeral Home became home to the Pierce County Sheriff's Department substation when the business closed. The substation operated between 1975 and 1985. This 1973 photograph includes Fred Reinicke (first car) and Harvey Gibbs (second car). The Mellinger Funeral Home–turned–police station was located at 9511 Bridgeport Way. It also served as one of the many locations the all-volunteer Lakewood Community Players used as a stage before it found a stage of its own, at what is now part of Lakewood Towne Centre. (Courtesy Pierce County Sheriff's Department.)

This 1983 photograph shows a group of Pierce County detectives on a prostitution sting operation, during the high-crime era of Lakewood's past. The officers used the "cover" of being car enthusiasts on their way to a car show. Pictured are John Solheim, Steve Bisson, Roger Gooch, Harlan Harris, and John Paterson, who owned the 1937 Packard. The sting involved driving up and down Pacific Highway in search of women for hire. (Courtesy Pierce County Sheriff's Department.)

Ray "Charles" Ames (center, in straw hat) played the role of Henry David Thoreau, while Dennis Cargill (third from right) played the role of Bailey in the Lakewood Playhouse production of *The Night Thoreau Spent in Jail* in the spring of 1991. The play was Ames's Lakewood debut, although he had been at Tacoma Little Theatre before that. He would later become a veteran of South Sound stages and even became the founder of the influential improv group the "Tokens." (Courtesy Lakewood Playhouse.)

During the early years of Fort Steilacoom Community College, now Pierce College, the infant drama program didn't have a stage of its own. It hosted plays in the Lakewood Community Playhouse for years, including a 1975 production of *Catch 22*. (Courtesy Lakewood Playhouse.)

119

Boo Han immigrated to America from South Korea and settled in Lakewood on March 3, 1973. His impact on the area grew from that first day. He settled his family into a 400-square-foot home along Lakeview and started a tofu manufacturing company in a nearby garage he built. He later started a grocery store for Asia products along South Tacoma Way. It was expanded in 1990 to keep up with demand after the demolition seen here. That 35,000-square-foot store is now the heart of the International District that offers several hundred businesses operated by people of Asian heritage. Han and his family operate similar grocery stores in Federal Way and Edmonds. His sons, Seung Han and Jae Han, run those sides of the business. (Courtesy Han family.)

Boo Han's wife, Bang, shares a laugh with her niece, Sangee Hwang, at the Boo Han Plaza in the late 1980s, before the 1990 remodel. Life would not be all smiles, however, as their niece was killed in a car accident in 1992. (Courtesy Han family.)

What started out as a small community of Korean families—often connected to soldiers returning from tours of duty around the Pacific in the 1950s and 1960s—Lakewood's International District offers a city within the city to anyone looking for ethnic goods, services, or food items. One of the prominent developers of this still-growing community is Boo Han, whose plaza provides a commercial anchor for the strip of South Tacoma Way. (Courtesy Steve Dunkelberger.)

The most colorful shop in Lakewood's history is the B&I Circus Store. Here, in 1958, former world heavyweight boxing champions Joe Louis, left, and Max Baer, right, pose with store owner E. L. Irwin. The B&I was also home to Ivan, a popular gorilla later sent to an Atlanta zoo, under public pressure. (Courtesy TPL, Richards Studio Series, D114282-4.)

The main building of Pierce College, then called Fort Steilacoom Community College, was erected in 1971. Temporary classrooms are in the foreground. The remaining hospital farmland became a county park in the late 1970s.

Marion Oppelt, left, Pierce College's founding president, discusses site plans with unidentified men in 1969, near land where the permanent campus is located. Oppelt had been deputy superintendent of the Clover Park School District when he was called on to open the community college in 1967, the year the state separated community colleges from local school districts. Before acquiring its present name and a branch in Puyallup, Pierce College was first called Clover Park Community College and then Fort Steilacoom Community College. Note that, far across Lake Waughop, there is an operating building of Western State Hospital that is now a ruin used for search-and-rescue training.

The Lakewood Mall replaced the Villa Plaza and then found itself being redeveloped after only 10 years of operation. The fall of the Lakewood Mall began when owner Basil Vyzis's shopping development was only five years old. It continued to flounder until MBK Northwest bought the property in 2000 and embarked on an ambitious redevelopment of the property, including the demolition of the enclosed mall. The new configuration became an instant draw for customers, especially with the Lakewood City Hall located on the outskirts of the property, providing a steady stream of passersby. The view below is of the town centre as seen from the third floor of city hall. (Courtesy Steve Dunkelberger.)

In 1995, after several years of active campaigning, the majority of Lakewood voters approved cityhood. In 1996, the then-editor of the *Lakewood Journal*, Walter Neary, was stumped over how to illustrate the cover of a special section of the newspaper about cityhood. He invited readers to visit the Lakewood Mall parking lot to pose as a group to illustrate the diversity and spirit of